Artists in Focus

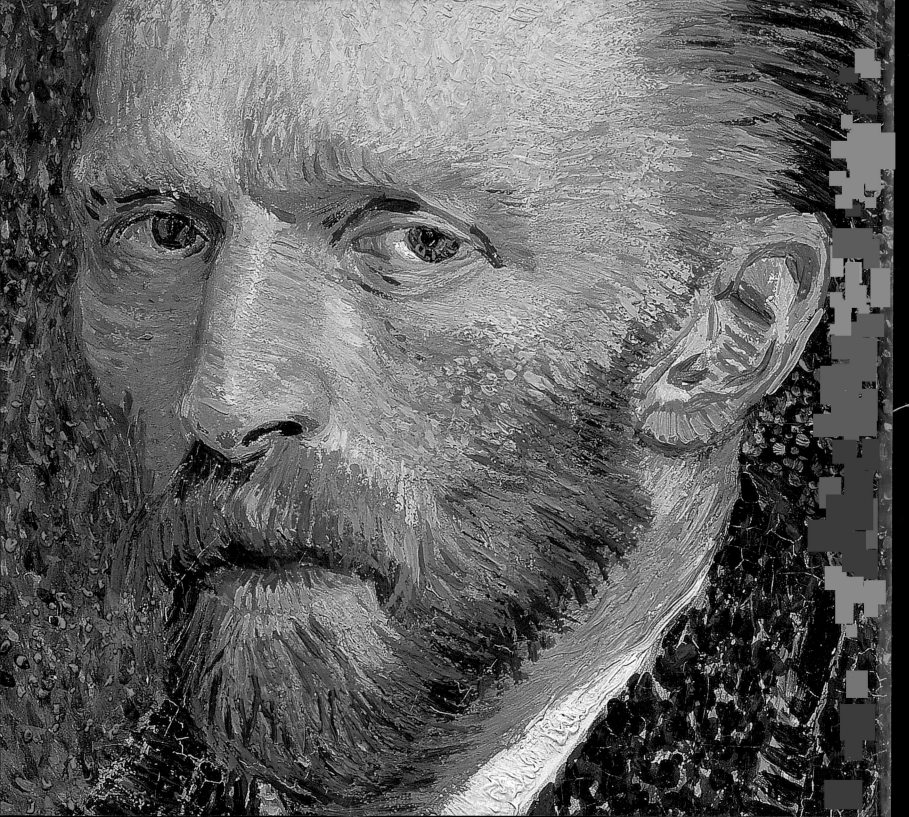

Van Gogh

Belinda Thomson

THE ART INSTITUTE OF CHICAGO

Distributed by Harry N. Abrams, Inc., Publishers

Produced by the Publications Department of The Art Institute of Chicago, Susan F. Rossen, Executive Director
Edited by Lisa Meyerowitz and Britt Salvesen
Photo editor, Karen Altschul
Production supervised by Sarah Guernsey and Stacey Hendricks

Designed and typeset by Joan Sommers Design, Chicago
Color separations by Professional Graphics Inc., Rockford, IL.
Printed and bound by Mondadori, Verona, Italy

Distributed in 2001 by Harry N. Abrams, Inc.,
100 Fifth Avenue, New York, NY 10011

Library of Congress Catalog Card Number 2001089785

ISBN 0-8109-6738-3

Photography, unless otherwise noted, by the Imaging Department, Alan B. Newman, Executive Director

All illustrations are of works by Vincent van Gogh in The Art Institute of Chicago, unless otherwise noted. Dimensions of works of art are given in centimeters, height preceding width.

Figs. 1, 2, 3, 4, 8, 16, 18, 19, 20, 28: Van Gogh Museum, Amsterdam (Vincent van Gogh Foundation). Fig. 5: © Rijksmuseum Amsterdam. Fig. 6: From M. Fidell-Beaufort and J. Bailly-Herzberg, *Daubigny* (Paris, 1975), p. 102. Fig. 7: © Musée des Beaux-Arts, Dijon. Fig. 10: Minneapolis Institute of Arts. Fig. 11: Musée de la Chartreuse, Douai. Figs. 12, 14: Glasgow Museums: Art Gallery and Museum, Kelvingrove. Fig. 13: Oesterreichische Galerie Belvedere, Vienna. Fig. 15: Musée Fabre, Montpellier. Fig. 21: From I. Walther and R. Metzger, *Vincent van Gogh: The Complete Paintings* (Cologne, 1997), p. 384. Fig. 23: The Metropolitan Museum of Art, New York. Fig. 24: Oskar Reinhart Collection, Winterthur. Fig. 25: © 1996 The Saint Louis Art Museum. Fig. 26: © Stichting Kröller-Müller Museum, photo by Tom Haartsen. Fig. 27: From Vincent van Gogh, *Correspondance complète de Vincent van Gogh* (Paris, 1960), p. 255. Fig. 29: From The Art Institute of Chicago, *The Joseph Winterbotham Collection, Museum Studies* 20, 2 (1994), p. 126. Fig. 30: Photo by Erich Lessing, Art Resource, NY. Fig. 31: The Museum of Fine Arts, Houston.

Cover: *The Bedroom*, 1889 (pl. 13)
Details: frontispiece (see pl. 7), p. 8 (see pl. 13), p. 15 (see pl. 2), p. 25 (see pl. 4), p. 33 (see pl. 8), p. 43 (see pl. 9), p. 51 (see pl. 10), p. 61 (see pl. 12), p. 69 (see pl. 13), p. 79 (see pl. 16), p. 87 (see pl. 6), p. 105 (see pl. 10)

Contents

Foreword

Familiar and beloved the world over, the art of Vincent van Gogh is imbued with emotion, whether the subject is landscape, portraiture, still life, or genre. It is always tempting to interpret van Gogh's work in relation to the details of his difficult life, but these well-known circumstances do not in and of themselves suffice to explain why his art remains so enduringly compelling to so many. The accessibility of van Gogh's oeuvre, which he aspired to achieve, exists in the context of the complex spirituality, multiple literary and visual associations, and sense of time and place that informed and enrich his art.

The Art Institute of Chicago's permanent collection includes sixteen works by van Gogh: eight paintings, seven drawings, and an etching. While this representation does not equal in number the museum's larger holdings of art by such near contemporaries as Edgar Degas, Paul Gauguin, and Claude Monet, it includes some of the Dutch artist's most important and signal works: a self-portrait from his second stay in Paris, *Madame Roulin Rocking the Cradle (La Berceuse)*, and *The Bedroom*. The latter two canvases were also the first works by van Gogh to enter the Art Institute. They are part of the famed Helen Birch Bartlett Memorial Collection, which came to the museum in 1926. The generosity of a number of other leading donors—Robert Allerton, Tiffany and Margaret Day Blake, Kate L. Brewster, Mr. and Mrs. Lewis Larned Coburn, Dr. John J. Ireland, the McCormick family, and the Joseph Winterbotham Collection—brought us other works by the artist. The museum continues to seek important examples by van Gogh, adding most recently (in 1998) a fine drawing, *The Carrot Puller*, thanks to a gift from Dorothy Braude Edinburg.

The Art Institute's connection to van Gogh deepened in 1950 with the presentation of the

first major retrospective of his work in the United States. That event prompted a memorable visit to Chicago by the artist's nephew, Vincent Willem van Gogh and included the display of *Sunflowers* and *The Yellow House*, among other important canvases. In 1962 the Vincent van Gogh Foundation was established in Amsterdam to govern the artist's works, letters, and examples of art by his contemporaries and to oversee the establishment of the Van Gogh Museum in 1973. A partnership between The Art Institute of Chicago and the Van Gogh Museum began in 1994, when the two museums undertook an important exhibition of the work of French artist Odilon Redon. This cooperation continues with "Van Gogh and Gauguin: The Studio of the South," opening in Chicago in September 2001 and in Amsterdam in February 2002. This path-breaking exhibition occasions the publication of *Van Gogh*, and *Gauguin*, the fourth and fifth vol-

umes in the Art Institute's ongoing Artists in Focus series, devoted to modern artists whose work is represented in depth in the museum's holdings (previous volumes are dedicated to Monet, Degas, and Renoir).

The illuminating text in this volume is the contribution of Belinda Thomson, an independent art historian living in Scotland who has authored several important publications on late-nineteenth- and early-twentieth-century French art. Her insightful interpretations of the works and their contexts and her perspective on the creation of his reputation enhance our understanding and appreciation of our holdings of the art of Vincent van Gogh.

James N. Wood, Director and President
The Art Institute of Chicago

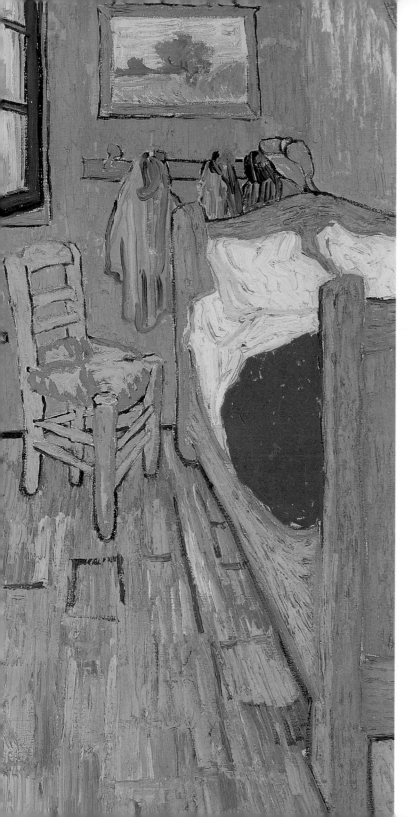

Vincent van Gogh thought that paintings should make a strong impression; once seen they should never be forgotten. By endowing his representations of everyday scenes with vigor through active surfaces and rapturous colors, van Gogh realized his goal and enabled us to see the world in a new way. The powerful effect of his art cannot be explained through technique and subject alone, however. It is the combination of his work with what his life and ideas have come to represent that together give the name Vincent van Gogh such resonance in the public imagination and make him a hero for our time who crosses barriers of age, class, nationality, and race.

For a number of reasons, van Gogh's oeuvre is now better known than that of any other painter of his generation. First, much of his work has remained together and found its permanent home in Amsterdam at the Van Gogh Museum

(established in 1962 by the Vincent van Gogh Foundation). His career as a full-time painter was short, lasting less than ten years, and despite his best efforts, he sold very little. Although he abandoned some of his early output, gave away several works, and exchanged others with fellow artists, he placed the bulk of his artistic production in the safekeeping of his younger brother Theo, an art dealer in Paris. This prudent move to ensure his work's survival reveals van Gogh's confidence in his art's importance and his reliance on his brother's support. The subsequent concentration of van Gogh material in Amsterdam has offered an unparalleled chance to advance scholarship. Nevertheless, The Art Institute of Chicago houses a group of important and representative pieces, including some of his best-known paintings as well as a number of striking and revealing works on paper, drawing being an activity he valued highly.

A second reason for van Gogh's renown is that the artist documented his development with great thoroughness, mainly through the numerous letters he wrote to his brother and others. Van Gogh's prolific correspondence evolved from his aptitude for words, seen in his initial impulses toward teaching and preaching, and as an antidote to his solitude. Accounts of him as an awkward teenager who was "not exactly silent" are consistent with later friends' and acquaintances' reminiscences of the torrent of words that flowed from him as he worked. Because of his letters, the trajectory of his career is well known and there are relatively few gaps in the chronology. The remaining arguments about dating often concern not which year to assign to a given work, but which month or precise day. His letters also inform us about his varied source material, much of which, ranging from the objects he painted—the family Bible, vases,

1. Vincent van Gogh, aged 18. Photograph. Van Gogh Museum, Amsterdam (Vincent van Gogh Foundation).

statuettes, and so on—to the prints and illustrations he collected, is preserved in Amsterdam. Augmenting the wealth of information found in these letters, the Van Gogh Museum has carefully documented his career and working methods, shedding light on van Gogh's media, brush sizes, pigments, and supports through technical examination.

Van Gogh communicated his ideas and methods so fully in his correspondence that it seems unlikely that he wrote merely to fill lonely hours or to commune with colleagues. Instead, as an avid reader of artists' biographies, he was conscious of inventing and conveying an artistic persona to the outside world; he strove to emulate the solid temperaments of the painters he heroized: Eugène Delacroix, Jean François Millet, Rembrandt van Rijn, and Théodore Rousseau. Unquestionably, he was aware of the potency of artists' words, as well as their works, to express ideas. On receiving a poignant letter from Paul Gauguin in October 1888, he advised Theo to keep it, designating him an archivist for the future: "Enclosed a very, very remarkable letter from Gauguin. Do put it aside as a thing of extraordinary importance." Appropriately, Gauguin remarked on van Gogh's fondness for the dictum "stone will perish, but the word remains."

A third reason for van Gogh's current international fame is his efforts to communicate with as broad a public as possible. For instance, by choosing to sign his work with his easily remembered Christian name, "Vincent," rather than his hard-to-pronounce surname, "van Gogh," he knowingly addressed himself to a wide audience. Like many Dutch, he was determined to project his experience beyond the confines of his small homeland. Working in Belgium, England, and France, he took care to perfect his command of these nations' native tongues, reading weighty

books in English and French and writing in both languages with impressive fluency. He enjoyed a wide international circle of friends, often falling in with other uprooted foreigners.

Moreover, for the most part, van Gogh chose subject matter that would be easily and universally understood, avoiding overt religious, literary, or historical narratives and concentrating on the straightforward genres of landscape, portraiture, and still life. Although individual paintings, such as the Art Institute's *Poet's Garden*, *Bedroom*, or *Madame Roulin Rocking the Cradle (La Berceuse)*, may carry complicated levels of meaning or literary associations to which he drew attention in his letters, they also operate at a more emotive and sensual level that is comprehensible, as he put it, to "anyone with eyes in his head."

Formation of the Artist, 1853–82

Vincent van Gogh was the eldest surviving son of a preacher in the Dutch Reformed Church. Brought up in rural North Brabant in a middle-class household that valued education, he was strongly imbued with the pastoral vocation. His father, Theodorus van Gogh, a much-loved parson in the parish of Zundert at the time of van Gogh's birth, was not the only professional churchman in the immediate family. The artist's grandfather and uncle were also ministers. Van

Gogh's own religious beliefs and evangelical, proselytizing impulses stemmed from the Christian teaching that he received at home and from a desire to live up to the example set by his elders, even though he would later come to regard his father's beliefs as narrow-minded and rigid. The mission to teach and preach, so essential to the job description of priest in the Dutch Reformed Church, resurfaced again and again in van Gogh's life, and influenced both the good relations he enjoyed and some of the misunderstandings that not infrequently arose in his dealings with others.

Van Gogh was born in 1853, shortly after the death of his parents' beloved firstborn, another Vincent, whose grave near the doorway to the local church was a familiar landmark throughout van Gogh's childhood. This fact has often been cited as one of the psychological influences shaping the artist's life. Perhaps, the sense of being the replacement son led to van Gogh's feelings of inadequacy and of having something to prove. It might also account for the confused love, respect, and hostility he showed toward his parents. Nevertheless, van Gogh (see fig. 1) experienced plenty of human warmth within the family, growing up surrounded by three sisters—Anna, Elisabeth, and Willemina—and two younger brothers, Theodore (Theo, as he was called, was four years his junior) and Cornelis.

Theo, initially looking to Vincent for guidance and following his lead into the art trade, would later sustain his brother both financially and emotionally throughout his career as a painter.

Another important facet of van Gogh's character was his Dutch heritage. For artists working in the increasingly dominant European tradition of realism in the middle of nineteenth century, Dutch painting had a distinctive, clearly defined character and occupied a highly respected place in the artistic canon. But the strength of van Gogh's attachment to his Dutch nationality and the extent to which he wished his own art to equal or embody the Dutch tradition are debatable. The Frenchman Eugène Fromentin, an artist who had earned considerable renown for his entries in France's official annual art exhibition, the Paris Salon, was the most widely read contemporary author to survey the Dutch school. His book *The Old Masters of Belgium and Holland (Les Maîtres d'autrefois)* was published in 1876, and we know that van Gogh read it for the first time in 1884. Another of van Gogh's favorite books also theorized about aesthetics: he first read George Eliot's *Adam Bede* (1859) in the mid-1870s. As a novelist, Eliot was not trying to depict an ideal world; accordingly, she preferred painters who depicted life as it really was. "It is for this rare, precious quality of truthfulness," she declared, "that I delight in many Dutch paintings, which lofty-minded people despise." In what amounted to an aesthetic manifesto of realism, she continued:

> Do not impose on us any aesthetic rules which shall banish from the region of Art those old women scraping carrots with their work-worn hands, those heavy clowns taking holiday in a dingy pothouse, those rounded backs and stupid, weather-beaten faces that have bent over the spade and done the rough work of the world— those homes with their tin pans, their brown pitchers, their rough curs, and their clusters of onions. . . . We should remember their existence, else we may happen to leave them quite out of our religion and philosophy, and frame lofty theories which only fit a world of extremes. Therefore let Art always remind us of them.

Such convictions became a virtual personal credo for the young van Gogh when he embarked on his artistic career.

More direct evidence of how van Gogh understood the character of Dutch art can be gauged from what he said about it himself. One of the clearest expositions is contained in a letter he wrote in October 1881 to fellow artist Anthon van Rappard, soon after each had made the crucial decision to devote himself to art. While the wealthy, young, aristocratic van Rappard chose this career path in a relatively light spirit, van Gogh, who had already failed in several

earlier undertakings, considered it a vocation to which one should give oneself, body and soul. He advised van Rappard (and by implication himself) against being too easily seduced by the French approach:

> In the beginning you should work from the *clothed* model. Most certainly one must have a sound knowledge of the nude, but in reality we have to do figures with clothes on. . . . You think a poor woman gathering potatoes in a field, a digger, a sower, a little lady in the street or at home, too beautiful not to feel the impulse to attack them in quite a different manner than you have done up to now. . . . [B]oth you and I cannot do better than work after nature in Holland (figure and land-scape). Then we are ourselves, then we feel at home, then we are in our element. The more we know of what is happening abroad, the better, but we must never forget that we have our roots in the Dutch soil.

This letter to van Rappard, with its references to fashionable, contemporary Salon artists in Paris, makes clear that he regarded paintings of the nude as strictly French terrain. Dutchness in art had to do with down-to-earth, material, peasant values, and was concomitant with a realist, rather than an idealizing, approach. Van Gogh sympathized with Émile Zola and other members of the French literary movement Naturalism, who viewed individuals as products of their environment and heredity and strove to represent nature faithfully, not to prettify it. Several years later, when van Gogh was in Arles and committed to radical art, he advised another young painter, whom he sincerely felt to be in need of solid guidance and teaching, to study the work of the best Dutch painters carefully. In so doing, he revealed the extent of his knowledge of their work, acquired during his early years as a student in the Netherlands, and their continuing importance to him even though he had left Dutch soil behind. The young painter was Émile Bernard, a proto-Symbolist. Van Gogh urged him to appreciate the Dutch masters for their healthy, essentially naturalistic qualities, instead of pursuing what he called the perverse, mystical tendencies now in favor. Bernard, he continued, should immerse himself in the work of Frans Hals, "that painter of all kinds of portraits, of a whole gallant, live, immortal republic . . . [and] the no less great and universal master painter of portraits of the Dutch republic: Rembrandt Harmensz. van Rijn, that broad-minded natural-istic man, as healthy as Hals himself." He continued, "I am just trying to make you see the great simple thing: the painting of humanity, or rather of a whole republic, by the simple means of portraiture. This first and foremost."

Yet, at the same time, van Gogh was by no means constrained by his sense of identity as a

The delicacy and vigor of the pen-and-ink hatchings, combined with the gnarled and twisted shapes of the stunted trees, give the work great poignancy.

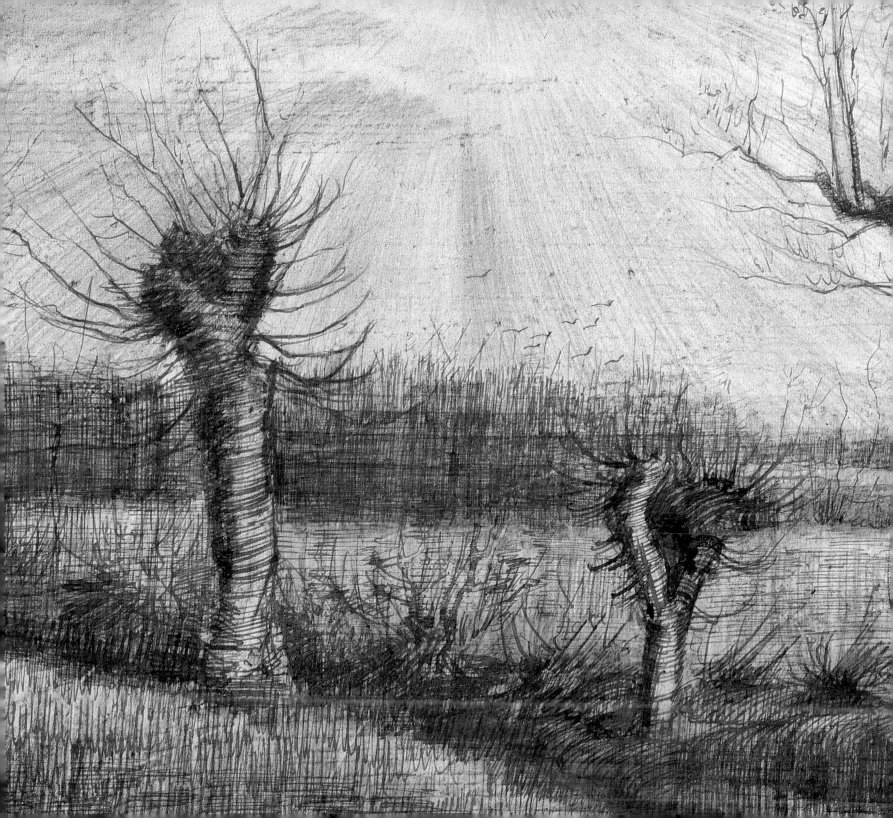

2. Exterior of Goupil et
Cie, The Hague, 1898.
Van Gogh Museum,
Amsterdam (Vincent
van Gogh Foundation).

came to painting, as well as identifying with his
contemporaries in the Hague School, he was also
passionate about the French realists of the
Barbizon School, from whom the Dutch artists
took their inspiration. Later, he drafted the
Romantics Delacroix and Adolphe Monticelli
into his pantheon of heroes; and by 1888 he saw
himself as belonging to a more general, modern
artistic renaissance, along with painters such as
Bernard, Gauguin, Georges Seurat, and Paul
Signac. Whenever he was pushed, however, as
for instance in heated arguments about aes-
thetics with Gauguin in Arles, the Dutchman in
him reasserted itself, and he returned instinc-
tively to his first love, citing Rembrandt as the
pinnacle of artistic achievement.

A synopsis of van Gogh's career from the age
of sixteen would show him wandering restlessly
from place to place, staying nowhere longer than
three years. His desire to find himself in this way
presents certain parallels with today's middle-
class, globe-trotting youth, eager to experience
cultural and ethnic difference while also seeking
the reassurance of cultural familiarity. In 1869
van Gogh began his first paid employment in
The Hague, working for his uncle Vincent,
known as Cent, who managed the branch office
of the Paris art gallery Goupil et Cie (fig. 2).
Goupil's specialized in selling French paintings
and photographic reproductions of canvases that

Dutchman. On the contrary, he was open in
outlook, alert to a multitude of different cultures
and artistic sources—English, French,
Japanese—although he seems to have been
somewhat suspicious of the suavity of classical
and Italianate influences. Despite this bias,
perhaps related to his failure to master Latin and
Greek, one of his projects was to go back to
drawing from Greek sculpture, a scheme he
never realized. He also considered international
outlets for his work. As a draftsman, he sought to
join forces with English illustrators. When it

had gained popularity at the Salon, as well as prints. In 1873, after going to the Paris head office and taking the opportunity to pay his first visit to the Salon, which he presumably saw through the eyes of a commercial dealer at a trade fair, van Gogh moved to Goupil's London branch. He then transferred once again, to Paris, but his heart was not in the job; he was asked to leave in early 1876.

With no clear prospects for the future beyond an idealistic wish to serve humanity and emulate his father, van Gogh returned to England in a new capacity, as a teacher at a boys' school. His English days came to an end in 1877, however, when he moved back to the Netherlands, to Dordrecht, determined to take up theological studies in earnest. He embarked upon the preparation for holy orders in Amsterdam, but soon abandoned his efforts, having despaired of reaching his goal through this conventional academic route. Instead, after a brief training in Laeken, near Brussels, he worked for several months as a lay preacher in the Borinage, Belgium's bleak coal-mining district. By the end of 1879, however, he had returned to Brussels, disappointed and disillusioned. There, after a year of soul-searching, he set his mind on a career as an artist, prompted apparently by Theo, who had just joined the staff of Goupil's in Paris. (Following a merger in 1879, the firm became

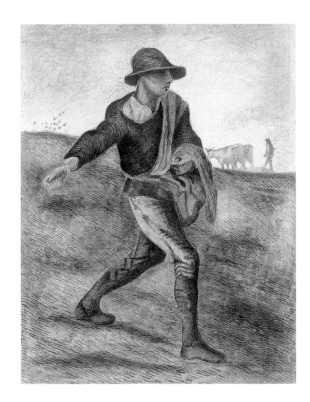

3. *The Sower (after Millet)*, early 1881. Pen and ink heightened with green and white wash; 48 x 36.5 cm. Van Gogh Museum, Amsterdam (Vincent van Gogh Foundation).

17

Boussod et Valadon et Cie, although many continued to refer to it as Goupil's.) Using his modest earnings, from 1881 onward Theo undertook to assist his father in supporting Vincent's new career.

Van Gogh embarked upon a program of self-instruction, using a reputable drawing manual by Charles Bargue (Pablo Picasso would later use the same book), and copying engravings after Millet (see fig. 3). He lived with his parents in Etten for a year, but before long he was again on the move. He spent almost two years studying art on his own, apart from some instruction from his

cousin the painter Anton Mauve, in The Hague. After this relatively settled period of urban existence, he spent four months working in rural Drenthe in northern Holland, and then fifteen months with his parents, who had relocated to Nuenen. He left Nuenen for Antwerp in December 1885, never to return to the Netherlands. His three months there served as a prelude to a more lengthy stay in Paris, Europe's main artistic capital, where he availed himself of his brother's hospitality. Van Gogh spent the final three years of his life, during which he emerged as an impressive painter, living first in Arles and St.-Rémy in Provence, and finally in Auvers, north of Paris.

A number of factors influenced these frequent moves, but high among them were van Gogh's vocational irresolution, his volatile character, his fundamental opposition to bourgeois conventions, and the consequent marginal nature of his lifestyle. Yet despite his aversion to settled existence, in other respects van Gogh behaved as the good-hearted, dutiful son. He punctiliously observed family rituals such as birthdays, and kept in touch through regular correspondence.

Van Gogh's idiosyncratic religious views were nurtured by his reading, particularly the works of Thomas Carlyle and Eliot. While in England between 1874 and 1876, he avidly devoured Eliot's early social novels *Felix Holt* (1866), as well as *Adam Bede*, and later recom-

mended them to others. Just as he claimed on occasion to identify with Felix Holt (he evoked the character's cultivated simplicity in his 1888 painting of his bedroom [see pl. 13]), it is tempting to suggest that, to some extent, he modeled his evangelism after that of Dinah Morris, the lay preacher and saintly Methodist in *Adam Bede*. Like her, he could always produce an appropriate biblical text to suit any occasion and was ever ready to comfort or console the grieving, but had little time for more orthodox liturgy. So too he took his religious mission to the industrial poor, tramping the countryside of the Borinage (perhaps the nearest equivalent he could find to Eliot's industrial "Stonyshire") in search of lost souls. As was the case with Dinah, those van Gogh encountered found his goodness sometimes inspiring, sometimes daunting, sometimes infuriating. One can well imagine the unrelenting zeal he brought to his preaching, for he later redirected it into his practice as an artist.

Van Gogh's neglect of his appearance and his deliberately spartan diet (he disdained rich, "bourgeois" fare) derived from the same homespun philosophy. Material possessions seem to have held little meaning for him, and he often gave away what little he had to those more needy than himself. Yet he did not resent paying for prints, books, and artists' materials. Perhaps, he was compensating for guilt over other aspects of

his conduct, such as his visits to brothels. We gain some insight into his own struggles with temptations of the flesh from the earnest advice he gave in 1877 to his roommate in Dordrecht; the artist counseled his friend not to marry until he was past forty, "after the passions are conquered, for only then can one seek to be a spiritual being with good results; the animal must get out, then the angel can enter."

One factor that occasionally precipitated van Gogh's sudden moves and prevented him from leading a settled existence was a series of disappointments in love common enough in a young man but exacerbated in van Gogh's case by his somewhat unrealistic attitudes toward the opposite sex. In 1881, at the age of twenty-eight, he fell hopelessly in love with his widowed first cousin, Kee Vos, and contemplated marriage, ignoring his own sage counsel not to do so. Like all of van Gogh's amorous adventures, this one was to be short-lived and unhappy. In fact it followed a somewhat self-destructive course, because his pursuit of Vos was fraught with difficulty and potential embarrassment, and was opposed not only by his parents but hers. The relationship ended bitterly, with van Gogh being banished from her home. After a final confrontation with and rejection by his uncle in Amsterdam, van Gogh abruptly moved from Dordrecht to The Hague.

The Hague, Drenthe, Nuenen, 1882–85

In 1882 and 1883, while living in Holland's capital, van Gogh concentrated his considerable energies on perfecting his drawing technique. His ambition was to produce work of an acceptable standard to be reproduced in one of the high-quality English illustrated journals such as *The Graphic*. He knew these publications well from his time in England in the 1870s, a veritable golden age for the pictorial press. It was with considerable delight that the artist came upon a cache of old issues in a bookshop in The Hague and managed to purchase them for next to nothing. By April 1882, he had procured enough such images to circulate them among friends and family and contemplate mounting an exhibition in a café. He had already succeeded in inspiring in his friend van Rappard a similar enthusiasm for English illustrators. The variety of media van Gogh explored at this date—including charcoal, black chalk, conté crayon, pen or brush and ink with white heightening—relates to his wish to find a working method suitable for reproduction in a technique such as wood engraving. This association also accounts for his occasional use of captions in English, "Sorrow," for instance, or "The Great Lady."

Van Gogh envisaged a career like that of the Anglo-German artist Hubert von Herkomer, who

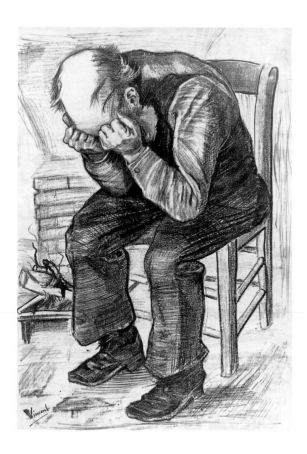

4. *Worn Out: At Eternity's Gate*, 1882. Lithograph; 50 x 35 cm. Van Gogh Museum, Amsterdam (Vincent van Gogh Foundation).

tion. Although he could admire the truth and simplicity of the works of the celebrated French illustrators Honoré Daumier and Paul Gavarni, at this stage of his career he mistrusted the cynicism of their attitudes to society, preferring, as he put it, the "noble and serious sentiments" he found in the English journals. During the winter of 1882–83, with *The Graphic* in mind, van Gogh devoted a whole series of drawings to depictions of the urban poor. He had a lithograph printed in November 1882, substituting for the words "Worn out," which he had inscribed on the drawing, the more portentous caption "At Eternity's Gate" (fig. 4). He left no ambiguity about his intended meaning, writing to Theo: "I have tried to express . . . what seems to me one of the strongest proofs of the . . . existence of God and eternity . . . in the infinitely touching expression of such a little old man, which he himself is perhaps unconscious of, when he is sitting quietly in his corner by the fire."

Van Gogh planned to use such images in an edition of prints that could be distributed among the working population: a selection, as he put it, of "thirty sheets of workmen types—a sower, a digger, a woodcutter, a plowman, a washerwoman, then also a child's cradle or a man from the almshouse. . . ." Because of this expressed ambition, art historians have sometimes mistakenly presented *The Graphic* as a popular journal

regularly contributed to *The Graphic*; he also identified closely with the socially committed subject matter and style of such artists as Luke Fildes and Frank Holl. Their drawings, and the literary interpretations placed upon them in the accompanying texts, betray the journal's typically English and typically Victorian moral purpose. They are directly comparable to the somewhat sentimental, consciousness-raising novels of Charles Dickens, such as *Hard Times*, which van Gogh had read with keen apprecia-

addressing the working class. On the contrary, it offered a varied and international coverage to an educated, predominantly middle-class readership. Tellingly, given its importance for van Gogh, *The Graphic*'s elaborate masthead for its first issue, in December 1869, features the twin muses of painting and literature linking hands over a sunburst. Alongside regular columns reporting yacht racing at Cowes or reviewing art at the Paris Salon, there were illustrated accounts of the Chicago fire of 1871 and the royal family's peregrinations around the British Empire. Among these depictions of world events and privilege, powerful images of the urban poor reminded the journal's readers of their obligations to the underprivileged, jolted their consciences, and prompted their charitable impulses. In the mid-1870s, *The Graphic* featured a series of full-page portraits under the rubric "Heads of the People," including Matthew Ridley's striking busts of miners. This series captured van Gogh's imagination, prompting him to draw his own figures with equivalent breadth and on a similarly grand scale, and later inspiring his ambition to paint a series of modern portraits.

The earliest work by van Gogh in the Art Institute's collection is a large, strong black-chalk drawing, *Weeping Woman* (pl. 1), datable to March 1883. It clearly belongs within this broad project of drawing contemporary urban types using techniques that could be easily adapted to graphic reproduction. The misery of the woman's pose repeats that of the little old man drawn a few months earlier in *Worn Out: At Eternity's Gate*. In *Weeping Woman*, however, van Gogh indicated a background setting more fully, with vigorous marks that fill the rectangle with atmospheric tone. The clear link between the two images should guard us from any temptation to read *Weeping Woman* as a response to a real-life situation. Although the model was Sien Hoornik—a destitute single mother with whom van Gogh had begun to cohabit and whose life he indeed perceived to be one of misfortune—it is clear that in this, and in the many related drawings he made of her, the artist carefully orchestrated his intended effects. His theme was sorrow, an emotional state in which, paradoxically, he found grounds for hope, taking his cue from the proverb: "When things are at their worst, they are sure to mend."

Certain details—the bulky folds of the woman's clothing, the upturned basket on which she sits, the cobbled paving—suffice to evoke a cheerless outdoor setting, either a yard or a street at night. The warm tone of the black lines and shading, which picks up the textures of the paper's grain, suggests that here van Gogh used "mountain chalk" (a natural, as opposed to fabricated, chalk), which he described that

month as yielding "a warm, peculiar black." Two days later, he returned to his theme: "Mountain chalk [unlike conté crayon, which he complained was lifeless] understands what you want; I would almost say it listens intelligently and obeys. . . ." In addition to the black chalk, there are applications of white chalk everywhere in the drawing and signs of a brush, particularly around the area of the basket.

Coincidentally, both van Gogh brothers were associating at this time with working-class women, Vincent in The Hague with Hoornik, Theo in Paris with a woman called Maria. Embarking upon missions of mercy, each had intervened into the lives of these women with a view to rescuing them from themselves. Vincent had undoubtedly projected onto Hoornik the symbolic traits of the fallen woman, movingly described by Eliot in the character of Hetty Sorrell in *Adam Bede*, just as he had embarked upon the liaison as a way of taking up man's burden of guilt toward womankind, wishing to atone for the moral shortcomings of the male sex in general. Art historian Carol Zemel has written trenchantly of the differences in power positions between van Gogh and his model, who, at the age of thirty-two, had experienced repeated pregnancies, abandonments, hardship, and prostitution. It should also be noted that he plunged headlong into this inappropriate relationship on the rebound from his cousin's rejection. The humiliation and disillusionment he had suffered still rankled keenly several months later and undoubtedly contributed to his rash decision, discussed airily in letters of May 1882, to marry Hoornik.

Van Gogh's bourgeois family and friends, notably his cousin Mauve, who led a respectable life in The Hague, expressed their disapproval. Hoornik had no obvious attractions, neither looks nor character nor intelligence, but van Gogh convinced himself that she needed him. She was also of course a convenient model. While she was ill, following the birth of her fourth illegitimate child, he looked after her, and in fact they lived together on the outskirts of The Hague for just over a year, creating a semblance of happy domesticity as she nursed her newborn son. It was a productive period for van Gogh, who incorporated Hoornik, her children, and her mother into many different compositions. But their relationship rested on such an uncertain foundation that, not surprisingly, it did not last.

Not long after making the Chicago drawing of a weeping woman, van Gogh began to speak more harshly of Hoornik's irredeemable character and social status, and of the inevitability, given the baleful influence of her ne'er-do-well family, of her returning to her former sinful ways.

His parents were no doubt relieved when he extricated himself from the situation. In January 1884, after he had spent a period of calming communion with nature in Drenthe, they agreed, albeit reluctantly, to take their prodigal son back into the fold.

In Drenthe—a remote area of waterlands and polders (reclaimed wetlands) in the northernmost part of the Netherlands, where the main source of revenue was peat cutting—van Gogh engaged in a campaign of peasant and landscape themes very much in keeping with the realist aims of the Hague School. He was also drawn to dwellings and the working lives of their peasant inhabitants throughout the months he spent in North Brabant, at Nuenen, where his parents now lived. One of Nuenen's traditional activities was weaving, a subject in which van Gogh had expressed interest several years earlier. By 1881 weaving in the home was considered to be a "disappearing industry," as is made clear by the caption on an engraving from the journal *L'Illustration* belonging to van Gogh. The weavers were mostly men, and the artist devoted himself to thoroughly exploring their craft. The women of Nuenen, when not assisting or spinning, did the bulk of the backbreaking work in the fields.

Eager to progress as an artist, van Gogh was unsparing of himself and attacked each of his

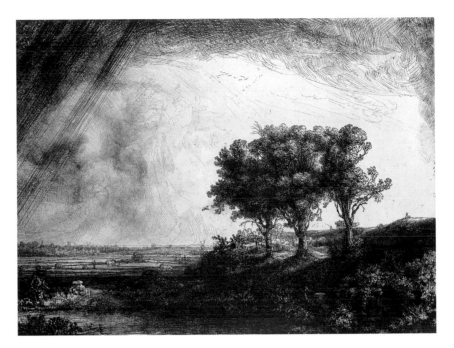

5. Rembrandt van Rijn (Dutch; 1606–1669) *The Three Trees*, 1643. Etching; 21.3 x 27.9 cm. Collection Rijksmuseum, Amsterdam.

new self-imposed tasks with application. He made rapid advances, as is demonstrated by Chicago's mixed-media landscape drawing of March 1884, known as *Pollard Willows* (pl. 2). The arrangement of the composition and the delicacy and painstaking nature of the technique suggest a deliberate desire on the artist's part to emulate effects found in Rembrandt's etchings. Although van Gogh's workaday scene does not strive after the same grandeur and pathos, it certainly bears comparison with the Dutch master's famous etching *The Three Trees* (fig. 5). Van Gogh's drawing was a virtuoso performance for an artist of only four-years' experience. The delicacy and vigor of the pen-and-ink hatchings,

Van Gogh likened the cottages of local peasants to "little human nests." He was clearly fascinated by the cottages' primitive construction, with walls of mud and roofs of straw, the thatch reaching down almost to the ground. . . .

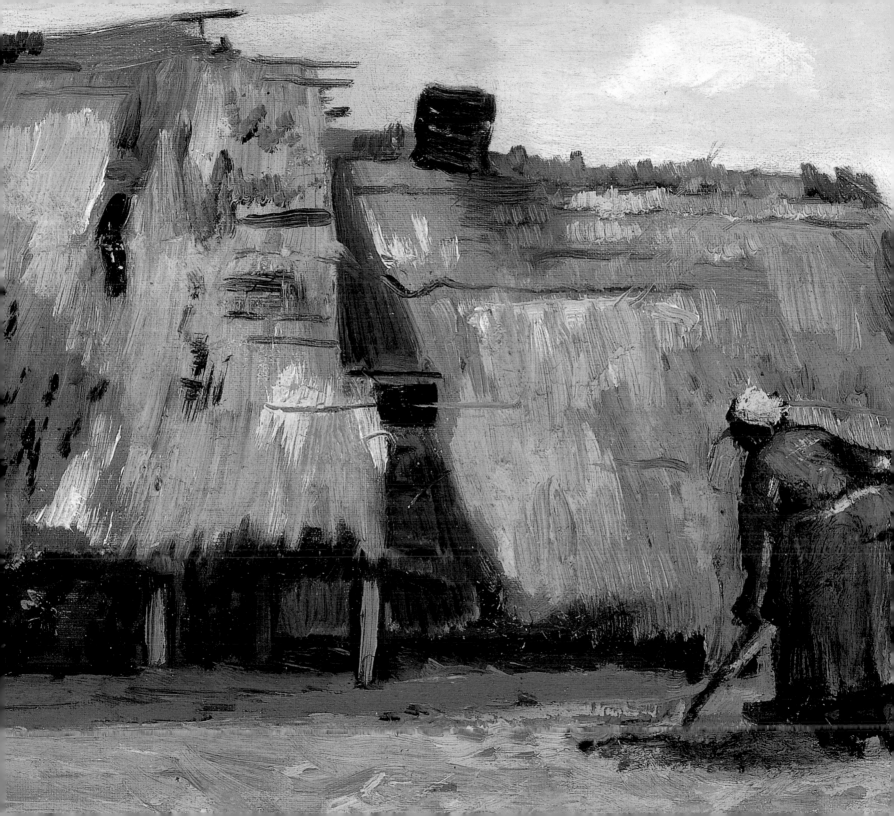

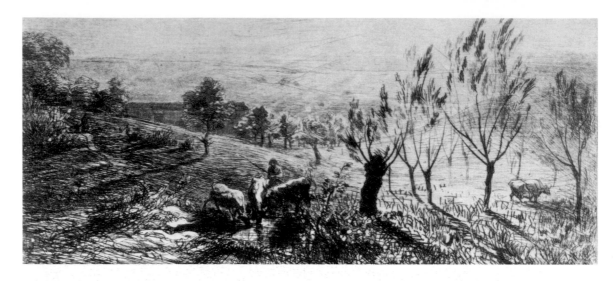

26

combined with the gnarled and twisted shapes of the stunted trees, give the work great poignancy. The trees seem to stalk, or mark out, the flat terrain, leading our eye by degrees toward the distant horizon. Only with careful scrutiny does one discern a stooping figure beneath the right-hand tree, working among the tall reeds that grow along the field's boundary, perhaps cutting them with a scythe or interweaving them to reinforce a man-made windbreak. Close examination also reveals van Gogh's remarkable technical finesse. He first established the composition in pencil and then overlaid the lower half of the composition, comprising areas of grass, trees, and reeds, with fine hatchings of ink. Although this ink now has a distinctly brownish color, at odds with the grayness of the graphite, in all likelihood it began nearer to black. As in his other

pen-and-ink drawings of this time, van Gogh probably used iron-gall ink, which discolors and fades with age. The time of day and lighting are indicated by a low, central sun, which radiates through thin, high clouds and spreads a glowing mantle over the entire scene, an effect that adds significantly to the landscape's drama. To achieve this effect, the artist first lightly but densely worked the sky in pencil; in fact, to establish a textural foundation on which to build the whole drawing, he seems to have laid the sheet of paper over a rough-grained wooden drawing board (he received two new boards in March 1884) and applied a frottage, or rubbing, technique, using the side of the pencil. One can clearly distinguish the horizontal striations of the wood grain in the top-right corner of sky. The discreet vertical division down the drawing's left-hand

7. Jean François Millet (French; 1814–1875). *The Carrefour de l'Épine, Fontainebleau Forest*, 1866/67. Pastel; 48 x 62 cm. Musée des Beaux-Arts, Dijon.

margin seems to indicate a join in the supporting board; a similar line appears in two comparable sheets in the Van Gogh Museum, but it is horizontal. Rather than using ink or pencil lines to denote the sun's rays, the artist apparently defined and refined them by judicious use of an eraser.

Van Gogh found this subject a short distance from his father's parsonage in Nuenen, where he had been living that winter. The date, March 1884, marks his seasonal shift from indoor, weaving subjects to outdoor work. The leaves were not yet out, but the worst of the winter weather had abated. The flatness of the terrain and the intensity with which it has been culti-vated—most notably in the trees, which were painfully constricted by the cutting and shaping imposed on them—give the subject a recogniz-ably Dutch character. It also has a certain time-lessness, and the sunburst perhaps hints at a loftier purpose. We know that van Gogh was familiar with Charles François Daubigny's 1861

etching after the Dutch Baroque artist Jacob van Ruisdael's *Sunburst* (1670s; Musée du Louvre, Paris), as he specifically mentioned in a letter getting hold of it and later urged his uncle Cent to buy a proof. However, in this instance Daubigny's own 1850 etching *Sunrise* (fig. 6) is a more pertinent comparison, as it too includes a sun, low on the horizon and emanating a halo of rays, in front of which a group of slender trees is silhouetted. Or van Gogh may have had in mind Millet's exquisite landscape pastels (see fig. 7).

But van Gogh's reliance on prototypes should not detract from the qualities of his drawing. *Pollard Willows* not only bears witness to his rapid technical progress to date but also anticipates the kind of motifs and draftsmanship that would preoccupy him several years later in Arles, by which time he abandoned the use of the fine-pointed metal nib in favor of the broader and more flexible reed pen. And it is the first appearance of the symbolic theme of the radiant sun or halo, so central to his imagery. Similarly pulsating rays around the sun appear in several important later landscapes, and there is even a halo of radiating brush strokes surrounding the central motif in his *Still Life with Grapes, Apples, Pear, and Lemons* (pl. 8).

Over the winter of 1884–85, van Gogh expended enormous energy to produce a painting on the theme of Brabant peasants, seated around a cottage table and eating their humble fare of potatoes. It has been suggested that the subject was inspired by Thomas Carlyle's description, in his book *Sartor Resartus* (1833–34), of peasants, or "white slaves," consuming their regular diet of potatoes. The artist meticulously prepared for *The Potato Eaters* (fig. 8) with drawings and oil studies of individual heads; he went out of his way to find suitably crude and ugly peasant types to pose and convinced himself that he had gone further in the direction of authenticity than other peasant painters, Jules Breton and Millet being the models he strove to emulate. He was thus severely disappointed by the lukewarm reactions to the canvas from van Rappard and then Theo (to whom he sent it in Paris), both of whom commented on its careless draftsmanship and lack of formal solidity.

Van Gogh produced the Art Institute's powerful *Carrot Puller* (pl. 3) in the wake of this disappointment. It belongs to a series of large-scale depictions of individual figures engaged in specific tasks, but isolated from their context. The drawing shows exactly how the left hand pulls the carrot, its fronds curling above it, from the soil while the right hand guides the head of a long-handled spade. Despite the reference to winter in a pencil note on the sheet (which may not be by van Gogh), evidence seems to indicate

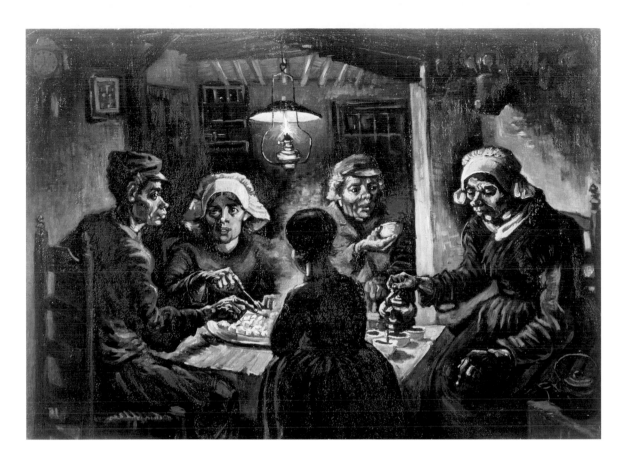

that the artist made the drawing during the summer of 1885. We know that during the months of harvest, van Gogh embarked upon a campaign of investigative, sculptural drawings of field workers, determined to give them the substantiality that van Rappard and Theo had felt lacking in *The Potato Eaters*. One could explain the mention of winter as an afterthought, connecting this sheet with its creator's desire to produce like Millet a "whole series on all kinds of work in the fields," each representing a different season. The woman he chose to draw was broad-hipped, an effect emphasized by the viewpoint from behind, employed in several of these drawings. Although one might query the anatomically awkward angles of the woman's left arm and shoulder, such niceties concerned van Gogh less than conveying the weight and volume of the figure and the effort involved in her action. The pose's exaggerated awkwardness is deliberate, and, while it underscores the brutal nature of the work, it also faithfully represents this woman's

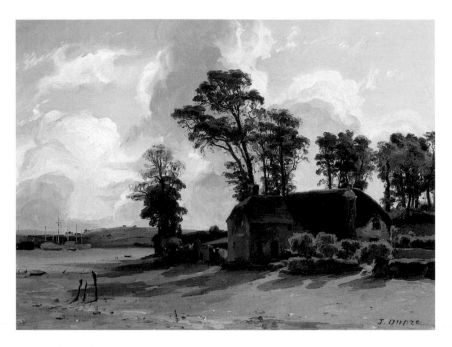

9. Jules Dupré (French; 1811–1889). *The Estuary Farm*, 1830–35. Oil on canvas; 33.7 x 47 cm. The Art Institute of Chicago, anonymous restricted gift in honor of John Gedo, 1995.186.

peculiarly bulky frame and the restrictions that wooden clogs imposed on bending and squatting.

A small study on board, *Peasant Woman Digging in Front of her Cottage* (pl. 4), is one of several paintings in which van Gogh likened the cottages of local peasants to "little human nests." It is surely no coincidence that at this time he was building a collection of birds' nests, which he encouraged local boys to bring him, and using them as still-life motifs. He was clearly fascinated by the cottages' primitive construction, with walls of mud and roofs of straw, the thatch reaching down almost to the ground, so much more redolent of human warmth than the modern, brick dwellings that he despised. In most of his studies, he included a figure or two, taking,

as he said, "rather great pains . . . to express their being at work, their *doing* something." It is by no means certain, however, that the title of the Chicago painting is an accurate description of what the woman seen from behind is doing; her left hand for instance does not grasp the shaft of the spade with the necessary force. Perhaps, van Gogh provided a clue to the nature of her work in a letter referring to one of the cottages' inhabitants, known locally as a witch. He cast doubt on the rumor: "When I came there, [she] did nothing more mysterious than turn over her potato pit." Presumably, such pits would have been used to store the tubers through the winter, and there is a distinct suggestion of a declivity in the ground to the figure's left.

In comparison with the dark, bituminous gloom of *The Potato Eaters*, *Woman Digging* is light in tone and brushwork, as are the others in the series. The artist whose palette and touch he seems to have emulated most closely here is Jules Dupré, who belonged to the so-called Barbizon School, a group of mid-nineteenth-century, French artists whose work emphasizes the simple and ordinary aspects of the land. A small landscape like Dupré's *Estuary Farm* (fig. 9) is remarkably similar in motif and tonality to van Gogh's *Woman Digging*. We know that van Gogh particularly admired the French artist's use of color: "Dupré is *perhaps* even more of

a colorist than [Jean Baptiste Camille] Corot and Daubigny."

But, by this date, Dupré lived essentially in van Gogh's memory; he had not seen his work for many years, and this made van Gogh anxious. He was becoming increasingly aware, because Theo frequently told him, that his own, dark paintings would look old-fashioned alongside the blonder palettes of his contemporaries in France. In saying this, Theo was probably thinking of such painters as Jules Bastien-Lepage and Jean Charles Cazin, although he would have also known the Impressionists. The only "Impressionists" Vincent could call to mind, however, were Dutch artists such as Isaac Israels, or French artists he could read about in the art journals, notably Edouard Manet, whose posthumous retrospective was held in Paris in 1884, and Jean François Raffaëlli, whose resolutely working-class subject matter he found sympathetic. Given van Gogh's strong commitment to oil painting around a base note of black, using the full resources of varnish and the deep resonance of earth tones, he understandably had considerable difficulty reconciling the reports of lightened palettes, bright colors, and matte, unvarnished surfaces. Although in theory he was convinced that an artist's choice of a color range is arbitrary and that there is no special virtue attached to working in a higher rather than a lower key, his letters show that he had begun to worry about the implications of "light painting." He knew it was time to confront the new tendencies head on.

Antwerp and Paris, 1886–88

"How glad I am to see the city again, much as I like the peasants in the country. How the bringing together of contrasts gives me new ideas —the contrasts between the *absolute quiet of the country and the bustle here*. I needed it badly." These words, penned to Theo in early 1886, reveal the degree to which Vincent consciously pitted the benefits of city and country against one another, which in turn partially explains his alternating between rural and urban environments throughout his career. In actuality he was not, as one might suppose, describing his feelings upon arriving in Paris, but in Antwerp, the home city of the greatest Flemish Old Master, Peter Paul Rubens.

Given van Gogh's current absorption in the problems of chromatics, Antwerp allowed him to test theory against practice, for Rubens was widely recognized as crucial to the colorist tradition. Van Gogh had spent time examining Ruben's famous *Descent from the Cross* (1611; Antwerp Cathedral). Among would-be artists in the late nineteenth century, Antwerp was also known for its Academy of Fine Arts, a consider-

The short, parallel marks, which animate the white cloth with a centrifugal swirl of pulsating light-blue and pink hatchings, possess a woven texture that no longer describes an actual basket; rather they infuse the whole composition with vibrations.

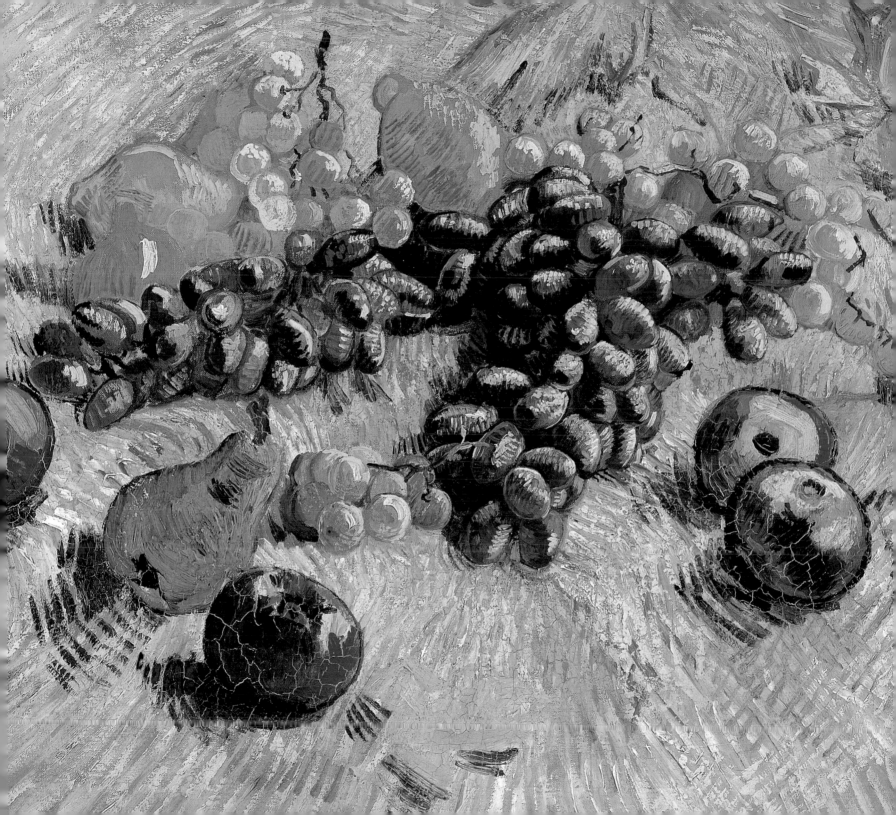

able draw to many foreign, particularly English-speaking students. They came, just as van Gogh did, in search of sound, practical instruction and the chance to work from nude models. Recent students in the atelier of Charles Verlat at the academy, where he enrolled, included James Guthrie, Edward Hornel, and other future Glasgow Boys, artists, who, like van Gogh, were influenced by Millet and French Naturalism. Bastien-Lepage's rural Naturalism was the dominant tendency; van Gogh, already long imbued with such ideas, found his short time there invigorating and confidence-building but not profoundly altering. He enjoyed watching others at work and matching his efforts with theirs and was not discouraged by the advice he received from tutors. Although they drew attention to his shortcomings, they also showed him a certain measure of respect for his hard-won facility as a draftsman. Their words fueled his ambition to study painting seriously in Paris, a plan he had first hatched six years earlier but had kept putting off until he was in a sounder financial position.

On March 1, 1886, Vincent arrived, somewhat precipitously, in Paris. He announced the news to Theo in a note, and suggested a rendezvous at the Musée du Louvre. Vincent instinctively gravitated to a place where he could confront the great masters of the past—in this instance, Delacroix—who had been so much on his mind recently. His eagerness to catch up with what was happening in contemporary art was equaled by this ongoing dialogue with tradition.

Van Gogh was certainly aware that the period he was to spend in Paris had the potential to make or break his development as an artist. At first he seems to have contemplated staying for only one year, moving on the following spring; in fact he stayed for nearly two full years, and his painting style underwent several major upheavals. The changes occurred, however, by fits and starts, and it is not always easy to plot a logical progress. The Art Institute of Chicago has four paintings dating from this period, which together admirably demonstrate different moments in van Gogh's rapid stylistic evolution. They also reveal his thinking: at times he was anxious to fall into line with the latest preoccupations of the Parisian avant-garde, while at others he pursued his own aims more single-mindedly.

Scant information exists about Vincent's movements and activities during his first few months in Paris. Because he was living with Theo, his primary correspondent, few letters survive to document this period of his career. We know that his brother's arrival forced Theo to move from his small flat on rue Laval to a roomier apartment at 54, rue Lepic, on the slopes of Montmartre. Vincent probably enrolled at

Fernand Cormon's studio in early autumn, after devoting himself to a concentrated campaign of flower painting—a practical and inexpensive way of trying out his theories about complementary-color combinations. Although the lessons added little to what he already knew, Cormon's atelier proved to be a valuable meeting place, and several of his closest artistic friendships—with Bernard, Louis Anquetin, and Henri de Toulouse-Lautrec—originated there. Clearly, van Gogh also devoted time in his first months to getting to know the smaller art dealers, particularly Alphonse Portier and Charles Emmanuel Serret (with whom he had already been in contact), Père Martin, and Julien (Père) Tanguy, as one reason for his move to Paris was to market his work. He had more or less given up hope of Theo's selling it through Goupil's, at least for the time being, but he nevertheless took an active interest in the art that Theo was handling and encouraged him to support more modern tendencies.

In displaying Vincent's art, Tanguy proved a valued friend and supporter. As a paint-supplies merchant, Tanguy had fallen into the habit of accepting paintings in lieu of cash; he thus had a stock of his clients' works and occasionally exhibited them in his window. With his particular brand of antiestablishment politics, Tanguy had a tolerant sympathy for the struggles of radical artists such as Bernard, Paul Cézanne,

and van Gogh. For van Gogh, his Montmartre shop became a regular port of call.

Odd though it may seem, until 1886 van Gogh appears to have had no contact with any Impressionist works. He had been in Paris briefly in 1874, the year of the first Impressionist exhibition, but at the time had been concentrating on promoting academic and Barbizon art on behalf of his employers. Between May 1875 and March 1876, when he was actually working for Goupil's Paris branch, he remained unaware of such new names as Claude Monet, Camille Pissarro, and Pierre Auguste Renoir, and of the discussions surrounding their emergent movement. His thoughts had been elsewhere (he was reading English authors and striving to become a better Christian), and his artistic interests had been focused on the landscape and peasant subjects of the French ruralist painters Breton, Dupré, and Georges Michel. He did not even see the Impressionists' second exhibition, held in 1876, because he left Paris soon after falling out with his employers on April 1, 1876—the very day the show opened.

Van Gogh was now understandably eager to see their work, as well as slightly apprehensive about how it would affect him. It crossed his mind that he might become "one of the club," as he put it in a letter to English painter Horace Mann Livens, although he quickly dismissed the

thought. In truth it was already a bit late to convert to Impressionism. The group had been exhibiting for a dozen years, and their eighth exhibition, held in the summer of 1886, when van Gogh could have seen it, lacked several of the style's original exponents. Although Edgar Degas presented a strong group of nudes there, Monet, Renoir, and Alfred Sisley did not participate. Because of rivalry and internal disunity—problems that van Gogh found hard to understand and strongly deplored—it would be the Impressionists' last attempt to make common cause in a group exhibition. It is not altogether clear from van Gogh's passing mention of Degas and Monet in the same letter to Livens whether in fact he visited that final show, although he certainly saw the Impressionists' works in dealers' galleries. It seems likely that his high hopes for the moment were somewhat dashed, for he later admitted that he had been disconcerted by what he perceived to be their general disregard for drawing and compositional structure.

Nonetheless, at the eighth Impressionist exhibition, certain new tendencies emerged that were to hold great interest for van Gogh, most importantly the systematic division of color practiced by the group the critic Félix Fénéon dubbed the "Neo-Impressionists." Van Gogh could not fail to have noticed Seurat's enormous *Sunday on La Grande Jatte—1884* (1884–86; The Art Institute of Chicago), which not only stole the show but was exhibited again at the Salon des Indépendants in the autumn, when it was the focus of all the critics' attention. It is not easy to imagine van Gogh's reaction to the painting, which is today one of the Art Institute's best-known masterpieces. In terms of color, Seurat deployed an exclusively blond palette and cultivated a matte, overall tonality, applying the paint in even, crisscross strokes, which he then overlaid with small dots. With its extraordinarily artificial, puppetlike figures in stiff and conventional poses, the *Grande Jatte* is a highly sophisticated, synthetic rendition of suburban leisure. Nothing could have been further from van Gogh's recent work, from the earthy tones he had used in *The Potato Eaters* or from the sincere efforts he had made in drawings and paintings to characterize the working postures of the Brabant peasants through a technique that in some sense related to their labors. In all likelihood, the *Grande Jatte* was just too big, too alien, too coolly detached, and too resolved a statement for him to countenance. On the other hand, he found the works of the artists associated with Seurat—Charles Angrand, Lucien Pissarro, and Signac—more modest in scale, less definitive in execution, and therefore considerably more approachable. These artists soon became highly significant figures for van Gogh; Signac in partic-

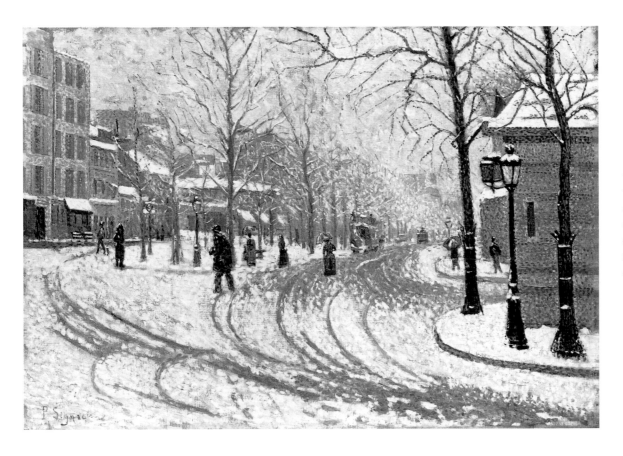

ular became a good friend and painting companion in the spring of 1887.

If he compared the work of his Paris contemporaries, it would quickly have struck van Gogh that the common trait they shared was a fascination with the unprepossessing aspects of the suburban landscapes of Asnières and Clichy. And he was probably well aware that the pioneer of this new type of subject was Raffaëlli. In effect Signac's *Paris, Boulevard de Clichy in Snow* (fig. 10) and some of his other Asnières scenes were essentially Raffaëlli motifs executed in a dotted manner, as critic Paul Adam pointed out in 1886. Van Gogh had depicted marginal areas in The Hague and, well before reaching Paris, had recognized Raffaëlli as an artist who chose subjects compatible with his own and shared his commitment to depicting humble, ordinary life. So it was hardly surprising that the Dutchman should fall so readily into line with this modern landscape approach, which Adam labeled "parisianism."

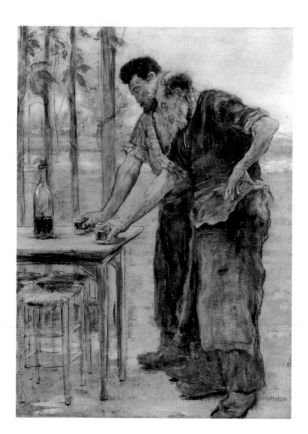

11. Jean François Raffaëlli (French; 1850–1924). *Blacksmiths Drinking*, 1884. Graphite and oil on cardboard laid down on panel; 77 x 57 cm. Musée de la Chartreuse, Douai.

Raffaëlli's reputation was considerable in the mid-1880s. Having aligned himself briefly with the Impressionists around 1880, he had gone on to stage his own successful solo exhibition in 1884. In 1885 van Gogh had expressed admiration for Raffaëlli's 1884 painting-cum-drawing *Blacksmiths Drinking* (fig. 11), which sets two dignified working men against a tract of waste ground, although he knew it only from a reproduction and perhaps from a Salon review. (In effect later he would take up a similar theme when he painted his copy of Daumier's *Drinkers*

[pl. 14]). By dint of clever courting of writers and critics, Raffaëlli had also made a success of a venture close to van Gogh's heart: illustrating the writer Joris Karl Huysmans's descriptions of indigents and desolate semi-industrial land-scapes, themes strongly associated with the democratic, Naturalist writing of Zola and his circle. In May 1889, Raffaëlli was celebrated in *L'Echo de Paris* in glowing terms by one of Zola's disciples, Octave Mirbeau: "Thanks to M. Raffaëlli, the Paris suburb—that intermediary and strange world—both teeming with life and desolate, which is neither city nor yet country, . . . has won its place in serious art." By 1890, when Theo, encouraged by Vincent, gave Raffaëlli a show at Goupil's, the artist was selling the majority of his production straight to American collectors. Incidentally, whereas Mirbeau went on to enthuse about van Gogh's work in March 1891, Raffaëlli, for his part, seems to have remained unaware of his Dutch admirer's achievements.

Over the course of his first autumn and winter in Paris, van Gogh made a sizeable group of landscapes featuring the Butte Montmartre, a short climb from rue Lepic, including Chicago's modest oil study, *Terrace and Observation Deck at the Moulin de Blute-fin, Montmartre* (pl. 5). Wind-mills, sited to take advantage of the crosswinds, were well-known features of this picturesque section of Paris. In other views, such as an earlier

composition now in Glasgow (fig. 12), van Gogh positioned himself some distance down the north-facing slope of the mound, away from the city, where the terrain was either used as allotments or for quarrying. Within a matter of years, all of this empty ground would be developed as housing; the Baedeker guidebook map of the area of 1881 already shows quite an intricate network of streets crisscrossing the slope. The overall tonality of the Chicago painting is more unified, limpid, and cool than that of the earlier work. It probably dates from the end of the winter of 1887, judging from the leafless state of the climbing plants, possibly vines. The paint layer is thinner and the brushwork more wispy, allowing pencil lines to show through. With its empty foreground and with a middle ground animated by small, anonymous, but socially identifiable, figures—two couples and a woman in a shawl—van Gogh's somewhat sparsely worked composition is reminiscent of those of Raffaelli, although it avoids the latter's overtly illustrative qualities.

The Blute-Fin windmill, also known as the Moulin de la Galette, was nonfunctional by this date, except as a tourist attraction and the site of a dance hall. The somewhat rickety wooden structure visible on the right of the composition is a viewing platform, from which visitors could enjoy a magnificent panorama of the city. In fact there are no buildings in sight in the Chicago painting,

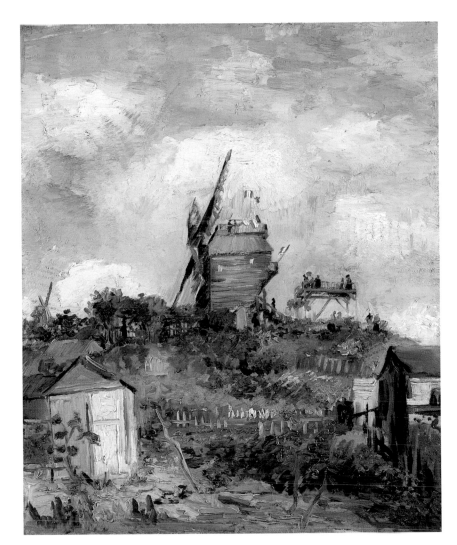

12. *Moulin de Blute-Fin, Montmartre,*1886. Oil on canvas; 46 x 38 cm. Glasgow Museums: Art Gallery and Museum: Kelvingrove.

neither on the mound nor in the haze that covers the city below, which looks like the sea. A picket fence separates the public space from the allotments and streets below, its regular vertical striations and lampposts indicated in metallic aquamarine blue, a recent addition to van Gogh's palette. It is likely that he used the orange of the

viewing platform to provide a complementary contrast to the pervasive bluish tonality.

Marcel Schwob, a writer on the cusp of Naturalism and Symbolism who wrote a column for *Le Phare de la Loire*, provided an intriguing account of the character of the Moulin de la Galette and its environs. On February 5, 1889, Schwob devoted an article to public dance halls, including the Moulin de la Galette, which Renoir had made famous in his ambitious multifigure composition of 1876 (Musée d'Orsay, Paris). Having described Montmartre by night, Schwob went on to evoke its very different atmosphere by day:

> On Sunday afternoons, under a bright sun, the scene changes. The streets are clean, the roofs sparkling. The dark wooden windmill stands out against the blue sky. . . . The miller who ran that mill made a fortune in the past, showing Paris off to the tourists. A little garden, laid out as a terrace, surrounds the [construction]; two platforms allow the curious to look down on the lake of fog that submerges the City of Light. Here and there, in the clear patches, one can vaguely see Notre-Dame, the Panthéon, the Invalides, the Trocadéro; sometimes a long strip of gray lace: it's the Eiffel Tower going up, still going up.

The writer's attraction to the scenery of Montmartre is a good example of the area's association, at this precise date, with artistic ambitions for urban realism.

Paris's suburban hinterland also forms the setting of another of the Art Institute's paintings from van Gogh's Paris period: *Fishing in Spring, the Pont de Clichy (Asnières)* (pl. 6), a canvas that fully demonstrates his new facility with the style and subject matter of Impressionism. Here, a small man seated in a flat-bottomed boat, his rod barely discernible against the light-blue water, whiles away a few hours fishing. In the background, we see a road bridge and a stark embankment. The bridge has been identified as the Pont de Clichy at Asnières, which was within walking distance of rue Lepic. We know van Gogh painted in Asnières on various occasions with Signac. The partially obscured view in this work seems to have been from one of the islets formed by the Seine. These islets, whose banks were left overgrown, were havens of tranquility for fishermen, despite the proximity of the bustling, industrial Clichy. It is intriguing to see how the moored boats were prevented from swiveling in the current by the poles wedging them into position. The banks of the Seine had been a favorite motif of the Impressionists for almost two decades, and Seurat had also explored the theme of fishing as part of his preparatory work for the *Grande Jatte*. But Monet is unquestionably the artist who comes to mind most forcibly here. It is possible that van Gogh saw Monet's 1882 painting *Fishermen on the Seine at Poissy* (fig. 13),

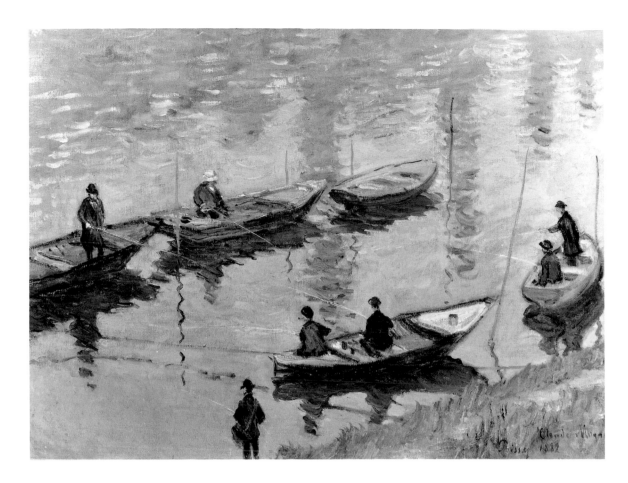

13. Claude Monet
(French; 1840–1926).
*Fishermen on the Seine
at Poissy*, 1882. Oil on
canvas; 60 x 81 cm.
Oesterreichische
Galerie Belvedere,
Vienna.

which belonged to the well-known Impressionist collector and operatic baritone Jean Baptiste Faure. Van Gogh recalled later how interested he had been in seeing part of Faure's collection put on display, picture by picture, in the window of a framemaker on rue Laffitte. Certainly, the motif and viewpoint are similar, although van Gogh, lacking Monet's skill at rendering the reflective surfaces of water, sensibly chose to interrupt the expanse of water with foliage and tree trunks.

Van Gogh used a distinctly Impressionist color scheme in *Fishing in Spring*, predominantly blue-green, mixed with plenty of white. Yet for all its freshness of palette, the painting is an odd amalgam of the free, spontaneous practice of Monet and the more calculated approach of the Neo-Impressionists. Van Gogh deliberately divided the tones into their constituent colors and introduced dots and dashes of pink, particularly on the far bank. That he was thinking in

Van Gogh described "a corner of a garden with a weeping tree, grass, round clipped cedar shrubs and an oleander bush. . . .There is a citron sky over everything, and also the colors have the richness and intensity of autumn. . . ."

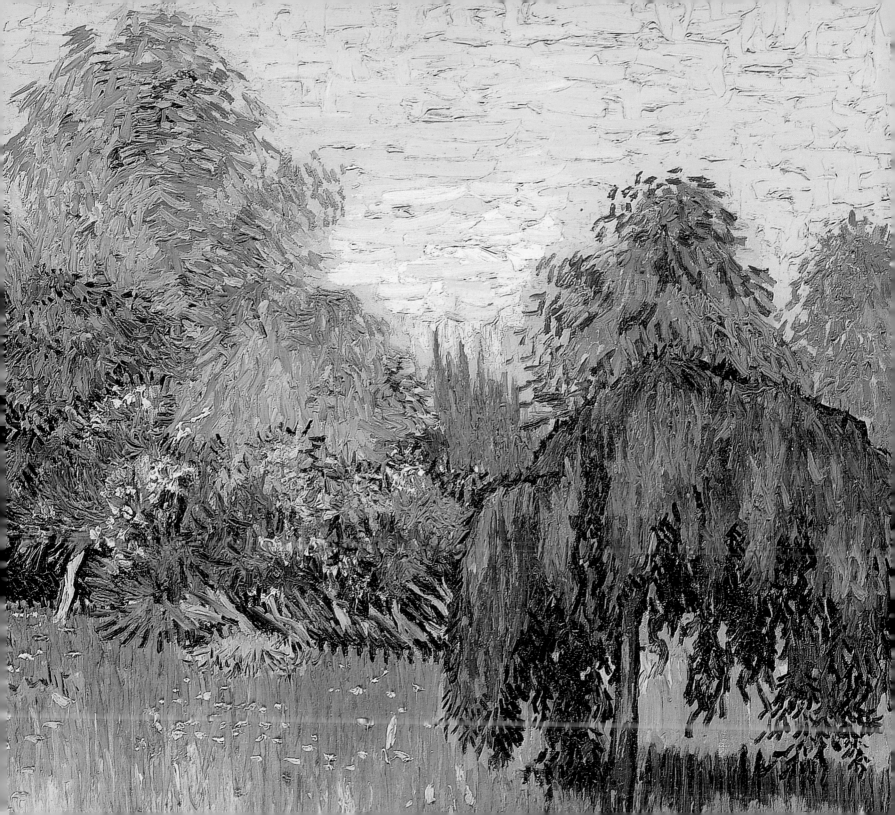

terms of established chromatic principles is further indicated by his decision to paint, in a free hand, a contrasting border of red, the complementary of green. This innovative device may have been influenced by the decorative qualities of Japanese prints, for van Gogh again used a red border around a blue-green composition in his *Bridge in the Rain (after Hiroshige)* (1887; Van Gogh Museum, Amsterdam), amplifying the red line with bands of green ornamented with Japanese-style script. Like the Neo-Impressionists, who were also experimenting with painted borders, van Gogh's attention to frames grew logically from his ideas about color theory. In Nuenen for instance, he had taken piano lessons in order to penetrate the idea, gleaned from Delacroix, of the affinity between musical tone and color, a concept that Seurat was exploring at precisely the same moment in France. And when trying to explain the importance of tonal relationships to a Dutch artist friend, he drew a surprising analogy: "Painting is like algebra: something is to this as that is to the other." From such indications, it is clear that van Gogh, far from working exclusively in response to his emotions, respected the intellectual aspects of painting, which he nourished by reading discourses by such authors as Charles Blanc, Félix Bracquemond, and Fromentin. Van Gogh was not the uncontrolled, purely expressionist artist some authors have led us to believe.

Calculations about color again came into play in his arresting *Self-Portrait* (pl. 7), which has been described as van Gogh's most "orthodox Neo-Impressionist" work in the genre. Yet here too he distinguished between the types of brush marks in different areas of the composition, rejecting the impersonal, uniform pointillism being practiced by Seurat and Signac at this date. For the background and the textures of the jacket, he applied the pigment in short jerky dabs, the underlying color quite close-toned, the overlaying red dots distinct and widely spaced. He built up the face, hair, and beard with finer, longer striations, more descriptive of the planes and textures they define. The overall tonality is far more rich and sonorous than in his suburban landscapes, harking back to some of his earlier Dutch oils. However open he may have been to contemporary techniques, van Gogh was not about to forget that his own compatriot, Rembrandt, had created some of the finest examples of self-portraiture. Indeed, van Gogh's self-portraits differentiate his preoccupations very clearly from those of his new French colleagues, just as his features and distinctive red hair forcefully emphasize that he was a man of the North.

The Art Institute's painting belongs chronologically somewhere in the middle of van Gogh's many Paris self-portraits, with a suggested date of late spring 1887. It shows him as a smartly

dressed man about town and closely parallels a portrait he executed of Alexander Reid (fig. 14), Theo's new Scottish assistant, which is almost identical in size and support. Vincent got to know Reid well in early 1887. They discussed a commercial venture together: the idea of investing in the production of Adolphe Monticelli, a recently deceased artist from Marseilles whose vigorous impastoed work both van Gogh brothers had come to admire and who already had a following in Britain and the Netherlands. The three men possibly imagined that they could repeat the success with Monticelli that the dealer Paul Durand-Ruel had had in buying up the studio contents of Théodore Rousseau after the Barbizon master's death. (Later, their shared interest in Monticelli led to conflict and a falling out.) In both portraits, van Gogh played up the complementary colors in a way that underscores the works' unusual hues, red against green in the Reid portrait, and blue against orange in the self-portrait (the blues in the latter have darkened considerably, which disturbs the tonal balance the artist intended). Reid and Vincent evidently were so physically alike that one could easily mistake them for brothers. As Theo also shared Vincent's features, the three of them must have been an interesting spectacle on boulevard Montmartre.

The number of self-portraits that van Gogh undertook at this time—over twenty-four—

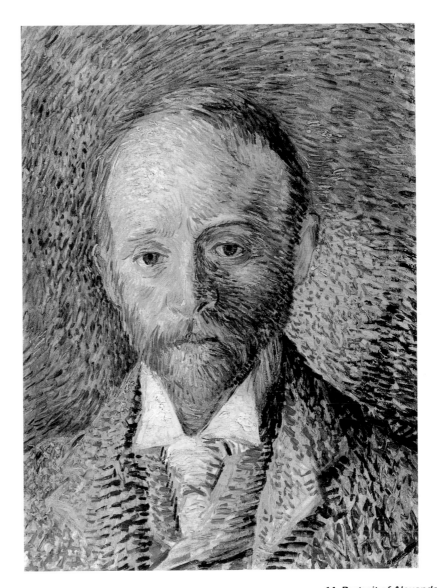

45

14. *Portrait of Alexander Reid*, 1887. Oil on cardboard; 41 x 33 cm. Glasgow Museums: Art Gallery and Museum: Kelvingrove.

is remarkable. In some, such as this one, he looks well kempt, in others rough and ready. Sometimes, he sports a city suit; more commonly he appears in the working man's blue jacket and straw hat he wore for outdoor painting, modeled on one he knew Monticelli to have worn. Van

15. Eugène Delacroix
(French; 1798–1863).
*Portrait of Alfred
Bruyas,*1853. Oil on
canvas; 116 x 81 cm.
Musée Fabre,
Montpellier.

ened his self-awareness and reminded him of a theory he once had formulated about his own physical type: "Certain reddish-haired people with square foreheads are neither only thinkers nor only men of action, but usually combine both elements." In 1888, when van Gogh and Gauguin were together in Arles, they made a trip to Montpellier to see the Musée Fabre, which houses the famous Bruyas collection. Van Gogh was struck by Delacroix's *Portrait of Alfred Bruyas* (fig. 15) and the physical resemblance he discerned between Bruyas, Theo, and himself. He welcomed this similarity, because here was yet another redhead who had in his own time been a great collector and supporter of modern artists. More to the point, perhaps, was van Gogh's now-established habit of working systematically, concentrating on a theme until he had exhausted it. Perhaps equally important was his need for introspection. Given the welter of possible distractions and alternative paths the city offered, he feared losing that firm sense of purpose and direction he had brought with him. Thus, although his Paris landscapes show him discovering and experimenting with Impressionism and Neo-Impressionism, there is a certain timidity in their thematic range. By contrast, in self-portraiture he felt free both to assert his personality and to project it through his technique. The underlying mood in the Chicago self-

Gogh's long-standing desire to paint portraits and the difficulty and expense of finding models are frequently cited as the reasons for this series. However, they do not fully suffice as an explanation. One might speculate whether coming to Paris, where he found himself surrounded by very different races and physiognomies, height-

portrait seems to be one of severity and defiance, rather than introspection or self-criticism, with much care taken to convey the sharp intensity of the eyes and set expression of the lips.

If self-portraiture was essentially a private theme that van Gogh could pursue without reference to his new-found colleagues, still life was a less intense genre to which he, like many artists, resorted at various junctures in his career, particularly when he was concerned with technical experimentation. Toward the end of his time in Nuenen, when his mind was full of Delacroix and the problems of mixing color, van Gogh had executed a series of still-life paintings of recently harvested apples and potatoes, which he sent to Paris. One of these, *Basket of Apples* (fig. 16), although to our eyes exceedingly dark (its heavy impasto a result of its having been painted over an earlier flower study), van Gogh executed in a very deliberate way. He explained to Theo:

> There is a certain pure bright red for the apples, then some greenish things. Now there are one or two apples in another color, in a kind of pink—to improve the whole. The pink is the broken color, created by mixing the first red and green mentioned. This is why there is a connection between the colors. Then I painted in a second contrast, in the back and foreground. One was given a neutral color by "breaking" blue with orange; the other

the same neutral color, only this time changed by adding a little yellow.

It is safe to assume that the same kind of deliberation went into the artist's color use and mark-making in *Still Life with Grapes, Apples, Pear, and Lemons* (pl. 8), painted two years later in Paris. The overall tonality here is much more luminous, but in essence the artist returned to, extended, and elaborated the highly individual form of striated brushwork already present in the earlier still life. The short, parallel marks, which animate the white cloth with a centrifugal swirl of pulsating light-blue and pink hatchings, possess a woven texture that no longer describes an actual basket; instead, they infuse the whole composition with vibrations. In this still life, van Gogh could almost have been giving a practical demonstration of theoretician Blanc's recommendations on color: "If one brings together sulfur [yellow] and garnet [dark red], which is its exact opposite, being equidistant from nasturtium [orange] and campanula [blue-mauve], the garnet and the sulfur will excite one another, because they are each others' complementaries."

There does not seem to be anything particularly meaningful about the choice of fruits in the Art Institute's still life. Similar fruits appear in the museum's impressive *Still Life with Apples and Grapes* (fig. 17) by Monet, which van Gogh may have seen in Paris. Monet, however,

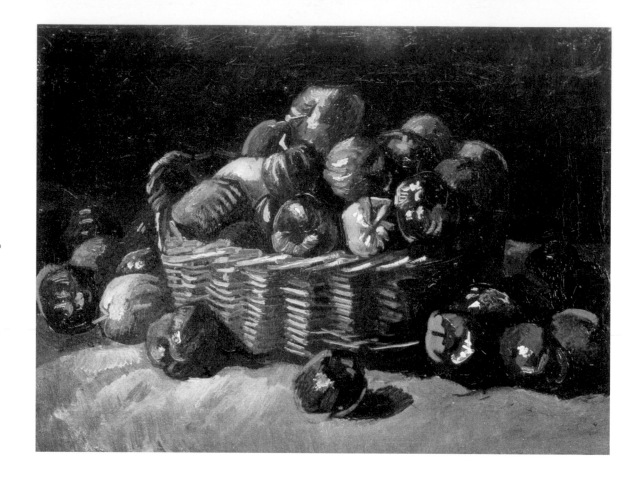

included a table-edge to anchor his composition in space. Van Gogh by contrast eliminated table and basket, separating the individual fruits one from another in a way that contributes to a semi-abstract, decorative effect. The same is true of his closely related *Lemons, Pears, Apples, Grapes and an Orange (with Frame)* (fig. 18), dedicated to Theo, which represents a different sort of color experiment. Here, the artist made a point of unifying his palette around a dominant yellow, initially surrounding this with another red border but finally carrying the yellow harmony onto the surrounding frame, in crisscross markings that resemble Japanese calligraphy.

These accomplished still-life compositions may well have featured in the impromptu exhibition van Gogh organized in November–December 1887, together with his friends Anquetin, Bernard, Arnold Köning, and Toulouse-Lautrec, at the Grand Bouillon-Restaurant du Châlet on avenue

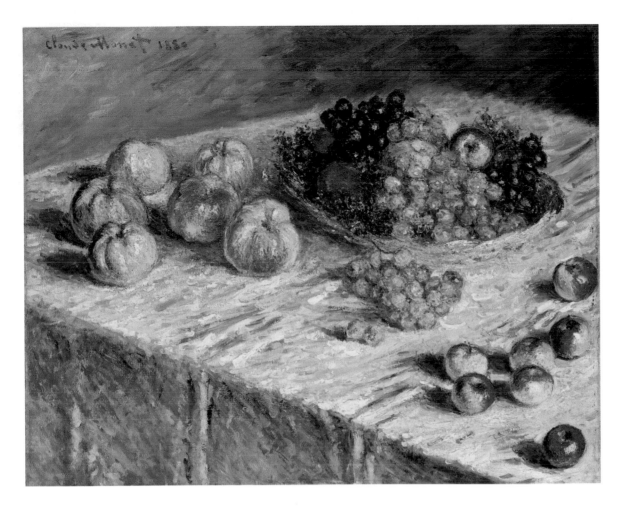

17. Claude Monet. *Still Life with Apples and Grapes,* 1880. Oil on canvas; 66.2 x 82.3 cm. The Art Institute of Chicago, Mr. and Mrs. Martin A. Ryerson Collection, 1933.1152.

de Clichy. Unfortunately, this ambitious undertaking, in which van Gogh hung about one hundred canvases, was forced to close early because of a misunderstanding with the restaurant's management and thus passed unnoticed by the press. But it was the result of van Gogh's energetic networking in Paris, and achieved, albeit briefly, his dream of seeing the artists of the "petit boulevard" (as he referred to those who had yet to achieve the status of showing with dealers on the "grand boulevard"), coming together in mutual cooperation and reaching out to the public.

Exhibiting work and selling it remained a high priority. Van Gogh was delighted that *Parisian Novels* (1887–88; private collection) was one of three canvases Theo exhibited on his behalf at the Salon des Indépendants the fol-

In the background, . . . the artist introduced a hectic floral wallpaper in green, blue, and orange, as if to demonstrate that flat planes only work when offset by patterning and texture.

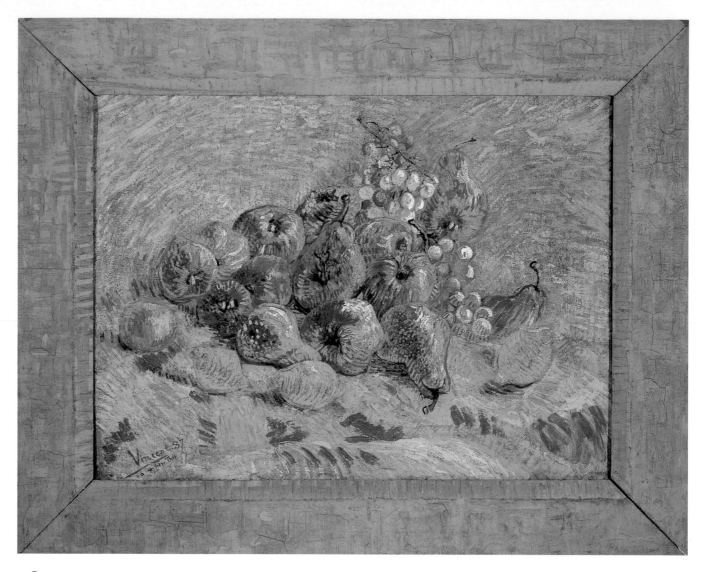

18. *Lemons, Pears,
Apples, Grapes and an
Orange (with Frame)*,
1888. Oil on canvas;
48.5 x 65 cm, with
frame 66.5 x 83 cm.
Van Gogh Museum,
Amsterdam (Vincent
van Gogh Foundation).

lowing year. But by the winter of 1887–88, too many other factors seemed to be militating against his achieving his goals. The intense cold had an adverse effect on his physical health, while his mental health suffered from the pressures of city life and art-world quarreling. In February 1888, to ease what was becoming an untenable situation, and to put some distance between himself and Theo, both of whom had found the experience of cohabitation trying, Vincent decided to leave Paris and head south to Provence.

Writing to Theo in mid-September 1888, after eight months in Arles, van Gogh was full of new-found optimism: "All true colorists must come to this, must admit that there is another kind of color than that of the North." In his chapter on color in *Grammar of the Arts of Design*, Blanc insisted on the palpable difference between the light of the North and that of the South. Van Gogh himself claimed that he had had a "thousand reasons" for moving south, but heading the list was his wish "to see in a different light."

Van Gogh had talked about leaving Paris for over a year before he left for Arles, in February 1888. He was aware that most of the painters he met found Paris an impossibly expensive and distracting place to work. For instance Gauguin, with whom he had become acquainted over the previous winter, had already pioneered the idea of painting in the completely "different light" of the tropics. Both van Gogh brothers enthusiastically admired the pictures he had executed in Martinique in 1887, and Theo began to buy the occasional canvas from the former stockbroker. As soon as Gauguin recovered from the illnesses that had curtailed his Caribbean stay, he was ready to leave Paris once more, largely for economic reasons, and head for Brittany in north-western France.

Shortly before Vincent left Paris in his turn, he and Theo had serious and wide-ranging discussions about how artists could combine forces in some practical way to safeguard their material existence, means of production, and share in the profits their pictures eventually brought. Two of the original Impressionists, Armand Guillaumin and Pissarro, who still struggled to make a steady income from their work, were party to these discussions, as was Pissarro's son Lucien. Whether they talked to Seurat, whose studio Vincent visited for the first time a few hours before his departure, is more debatable: Seurat's situation was rather different in that he enjoyed a sufficient private income. When van Gogh left Paris, he carried away with him the dream of forming a studio in the South, which other artists could join. Although he was not seeking to exclude anyone from his thinking, from May onward the plan began to crystallize most promisingly around actual premises and a likely first recruit, Gauguin.

John Russell, a well-to-do Australian painter whom van Gogh had met while studying at Cormon's studio in Paris, may have played a part in recommending the light of the Mediterranean. He had been on a walking tour of Spain in 1883 with fellow Australians and in 1886 had spent time in Sicily, where he painted a series of orchards in blossom. Russell was one of van

53

Gogh's main correspondents during his first year in Arles, when he executed a series of orchard paintings of his own. He wanted to explore with Russell the musical idea of working in different "keys," something he felt Russell had achieved when he shifted genre and mood from portraits to spring orchard landscapes; this flexibility was a quality he sought to emulate.

The second important aesthetic reason that van Gogh gave for heading south was the thought "that looking at nature under a bright sky might give us a better idea of the Japanese way of feeling and drawing." His love of Japanese art had grown during his Paris stay. In fact van Gogh, who had started to collect Japanese prints in Antwerp and continued to do so in Paris, was a prime mover in disseminating an enthusiasm for Japanese art among his "petit boulevard" circle. In March 1887, he had organized an exhibition of his collection of Japanese prints at the Café du Tambourin in Paris, urging his new artist friends to study them. Intentionally or not, they served as a corrective to the diffuseness that resulted from the Neo-Impressionist touch, which some regarded as problematic. Instead of hazy forms, Japanese prints offer crisp outlines; their colors, whether bold or muted, sometimes present a variegated texture because of the crinkled crepe paper on which they were printed, but they are clear-cut and distinct, not broken into vibrating patches. In the wake of this exhibition, Anquetin and Bernard abandoned stippled effects and began experimenting with new ways of manipulating pigment. They also made changes to their compositions, developing a radical and distinctive manner consisting of strong outlines and solid color areas, which the critic Edouard Dujardin labeled "cloisonnism" because of its resemblance to the medieval enameling technique involving metal *cloisons*, or partitions. Van Gogh's fascination with Japanese art, characteristically, led him to make a series of painted copies after the early-nineteenth-century Japanese masters Ikeda Eisen and Utagawa Hiroshige (see fig. 19); this exercise taught him several important lessons as he translated flat, woodblock effects into the much more tactile medium of oil paint.

The factors that led van Gogh to choose Arles, in Provence, as his destination are still not entirely clear. A moderate-sized town on the banks of the Rhône, it is situated at the point where the river divides and the terrain flattens out to form the Camargue, a strangely desolate, alluvial estuary. Was he actively looking for an interesting place to go, which Arles certainly was, or merely seeking an alternative to Paris? Had someone, perhaps Toulouse-Lautrec, a native of southern France—recommended Arles to him? Why did he not continue his southward journey

fifty-five miles further to the port of Marseilles, where Monticelli was born? He would have associated the Provençal area with certain writers, such as Zola, who came from Aix, and Alphonse Daudet, whose Tartarin stories about nearby Tarascon he read as soon as he got to Arles. The one cliché about Arles of which van Gogh cannot have been unaware was the reputation of local women for outstanding beauty. The artist's nephew Vincent van Gogh suggested that his interest in them may have been aroused by the Dutch author Multatuli's *Max Havelaar* (1860), which devotes an entire chapter to a discussion of the beauty of the Arlésiennes.

It is worth noting that van Gogh's letters are remarkably silent about Arles's past glories as a Greek and then Gallo-Roman center in his letters. He scarcely mentioned its rich, classical heritage and many archeological glories—from the Roman arena and theater to the Cathédrale Ste.-Trophîme and the Musée Lapidaire. Similarly, the Alyscamps, an ancient necropolis to which coffins were reputedly sent from far and wide (and sometimes floated unescorted down the Rhône with the money for burial), seems not to have been a source of reflection but rather just another public park. In an October letter, however, van Gogh mentioned that the Greeks had observed the cult of Venus in the Arles region. The artist seems to have had no prior knowledge

19. *Flowering Plum Tree (after Hiroshige),*1887. Oil on canvas; 55 x 46 cm. Van Gogh Museum, Amsterdam (Vincent van Gogh Foundation).

of the lively contemporary literary revival in the South, called the Félibrige and led by Clovis Hugues, Frédéric Mistral, and others. He did not mention this group until mid-October 1888, and the fruitful artistic exchange that he vaguely envisioned never materialized.

At first van Gogh seems to have responded to Arles with a detached and distinctly northern vision. It is important to remember that he was still partial to Naturalist literary ideas, and thus

more aware of the ordinary residents and their struggles for life within a particular environment than alert to the romance or historic associations of buildings. Interestingly, Gauguin would find this fascination with lowlife entirely alien. In van Gogh's first Arles paintings, just as in his recent campaign to depict unprepossessing suburban landscapes in Paris, Arles is either excluded or seen from a distance, looking much like any other modern, semi-industrial southern town. It is intriguing to speculate whether he read any studies specific to Arles. Charles Lenthéric's *La Grèce et l'Orient en Provence: Arles—Le Bas Rhône—Marseille* (1878), a mix of economic information, cultural history, and legend, would surely have fueled his associations between Arles and the East, and between the Arlésiennes and their noble Greek heritage. Lenthéric's preface begins:

> What strikes me about our Provençal region is the profound imprint that oriental migrations have left on it. Provence is still the Orient. It has the Orient's color, immense horizons, vast empti-nesses, its mirage and dazzling light; and if some-times it shows pride in the beauty of its women, that is because they have retained in their eyes a glint of the Orient's sun. . . . On our Gallic soil, Arles and Marseilles were the real homes of those first oriental civilizations. . . . Equally illustrious in the past, their present fortunes could not be more

contrasting: the former is in a sad state of decline and seems oblivious of its vanished greatness; the latter, gay, lively, still youthful, is absorbed in its material interests and thinks only of making the most of the present. Both have lost the memory of their origins.

Despite Lenthéric's image of Arles as a place in decline, it had been offered an entrée into the modern world in the form of the railway. The main Paris-Lyons-Marseilles line passed through the town (very close to the famous Yellow House that van Gogh would rent in May and inhabit from September onward), thanks to the inter-vention in the 1840s of the poet Alphonse de Lamartine in his capacity as a local politician. He was honored in the naming of Place Lamartine, the square opposite the Yellow House. The proximity of the railway was of considerable practical value to van Gogh when he needed to send crates of pictures north; he also painted views of railway bridges and the Rhône.

During his first few months in Arles, van Gogh lived a hand-to-mouth existence, staying in a cheap hotel, then at the Café de la Gare, and spending long days painting and drawing out of doors. He concentrated on landscapes, working first on views of orchards and then of the vast plain of La Crau, which he found inspiring, reminiscent of Holland and suggestive of Japan. As the artist began feeling his way into the

variegated textures of this arid land, which he described as echoing with the insistent song of the cicadas, he realized that it demanded to be drawn. Much of his energy went into a series of bold and intricate reed-pen drawings on identically sized sheets of paper. They are some of the most innovative works of his career. But practicing his art in the South was not as easy as he had hoped: models for portraiture were scarce, and open-air work often involved battling with the hot sun and the unforgiving mistral wind, which funneled down the Rhône valley.

If indeed the illness that began to afflict him later in the year and haunted him thereafter was acute intermittent porphyria, as one medical expert has recently proposed, it was probably exacerbated by this unremitting labor in heat to which he was not accustomed and by his excessive consumption of alcohol. (The precise nature of van Gogh's illness has given rise to much speculation. He and his doctors believed it to be a form of epilepsy; his attacks were relatively short-lived, leaving him unchanged in between. The symptoms during such episodes, however, which occurred with increasing frequency in the last years of his life, were similar to those experienced by sufferers of manic depression and schizophrenia. After December 1888, he lived in fear of their recurrence and speculated whether or not he was becoming insane.)

Van Gogh was greatly relieved to move into the Yellow House (see fig. 20) and finally set up his studio there. Over the summer of 1888, he was careful to keep Theo abreast of every expense involved in acquiring furniture for his new, two-story house. At one level, indeed, one can consider the initial painting of his bedroom, completed in the third week of October 1888, as a record of the simple, irregularly shaped room and an account of the money spent furnishing it. But it is also a celebration of van Gogh's first proper home, and of the restful sanctuary his bedroom offered, especially when the cool green shutters were drawn against the punishing afternoon sun. He painted his first version of the subject, now widely held to be the canvas in the Van Gogh Museum, Amsterdam (fig. 28), shortly after he had woken from a long sleep occasioned by a spate of exhausting work. Gauguin's visit was imminent, and in anticipation of his artist friend's arrival, van Gogh was attempting to embellish his house, with a considered, decorative scheme of pictures, all of the same size. He began a series of paintings of sunflowers in August, then added portraits, the view of his bedroom, and garden subjects to complete the arrangements.

As the greenish light at the window hints, the artist's bedroom looked directly over Place Lamartine, which was laid out as a public park to

20. *The Yellow House*,
1888. Oil on canvas;
72 x 91.5 cm. Van Gogh
Museum, Amsterdam
(Vincent van Gogh
Foundation).

serve the northern edge of the town. The pre-
vious year in Asnières, van Gogh had painted
views of a public park, which he associated with
courting couples; in Arles too he set about
painting views of the Place Lamartine gardens.
In fact the space was divided into three gardens,
each having a rather different character. The
section with the densest foliage and shrubberies
of oleanders was furthest from the river and
adjoined a street leading to a brothel. Its shady

greensward is the subject of Chicago's *Poet's
Garden* (pl. 9), executed in mid-September 1888,
a simplified and resolved version of a smaller,
first rough draft, *Garden with Weeping Tree* (fig. 21),
which Vincent had already sent to Theo in July.
In mid-September he was working furiously,
sometimes on several canvases a day.

On completing the Chicago painting,
van Gogh described it to his brother in detail:
"A square size 30 canvas, a corner of a garden

with a weeping tree, grass, round clipped cedar shrubs and an oleander bush. . . . There is a citron sky over everything, and also the colors have the richness and intensity of autumn . . . it is in even heavier paint than the other one, plain and thick." The one detail he omitted in his description was the bluish tower of Ste.-Trophîme, the only extraneous element in its green-and-yellow color scheme. In effect van Gogh was now using his heavily laden brush with the same rhythmic emphasis as his reed pen, making no attempt to divide colors or soften the edges of brush strokes, each of which is a distinct element in the gradually built-up surface texture. In this he consciously emulated Monticelli, writing to Theo around September 27: "Altogether I can't help laying it on thick in Monticelli's manner. Sometimes, I think I really am continuing that man's work." Just as he would later envisage hanging the *Sunflowers*, with their dominant yellows and blues, next to the red and green of *Madame Roulin Rocking the Cradle (La Berceuse)* (pl. 10), he also linked these garden canvases to his café scenes, their keynote of green offering a startling complementary contrast to the red dominating the interior of his *Night Café* (1888; Yale University Art Gallery, New Haven, Conn.).

On October 8, van Gogh announced that the "two pictures of *The Poet's Garden* framed in walnut," were ready to hang in the room where

21. *Garden with Weeping Tree,*1888. Oil on canvas; 60.5 x 73.5 cm. Private collection.

Gauguin would sleep. The following year, he presumably sent the Art Institute's painting to Paris. In an intriguing detail concerning his attitude to the oil medium and its conservation, he later recommended that, provided they were "quite quite dry, Theo should wash certain canvases, especially the landscape that was in the walnut frame, with *water and a little spirits of wine* to take away the oil and the essence in the impasto." It would be intriguing to know whether the "certain canvases" includes Chicago's *Poet's Garden*, and whether the procedure was carried out. It was a method recom-

Van Gogh used the reed pen to detail the cypresses' branches as paisleylike swirls, as if the trees were entirely engulfed in flames. . . . Like the sunflower, the tree symbolizes a universal life-force.

mended by Gauguin to lessen the fat content of the paint, thereby enhancing the matte quality of the surface and diminishing its irregularities.

The Chicago painting was the first of a group that van Gogh thought of as "The Poet's Garden." He seems to have derived the idea from an article on Renaissance literature in the July 1888 issue of the *Revue des deux mondes*, which includes descriptions of Petrarch's garden; through a complicated series of poetic associations, he gradually honed his concept to a single idea: "What I wanted was to paint the garden in such a way that one would think of the old poet from here (or rather from Avignon), Petrarch, and at the same time of the new poet living here—Paul Gauguin. . . ." It was no coincidence that these connections occurred to van Gogh just when his protracted and anxious luring of Gauguin to Arles was nearing fulfillment. For some van Gogh seems to have cast himself, consciously or not, in the role of Boccaccio (Petrarch's amanuensis) to Gauguin's Petrarch. Van Gogh was in awe of what he saw as Gauguin's superior poetic and artistic depth; he judged his own greatest quality to be the directness and sincerity of his relationship to nature, but he feared that his art would look unduly coarse beside Gauguin's. Reading the confident letters from Gauguin and Bernard (who joined Gauguin in Pont-Aven in mid-August) about the radically synthetic and antinaturalistic paintings they were producing together in Brittany, notably Gauguin's description of his religious painting *Vision of the Sermon* (1888; National Gallery of Scotland, Edinburgh), certainly challenged him. The Dutchman's nervousness about "abstractions," as they called them, probably accounts for his striving in a slightly forced way to endow his garden paintings with poetic and literary associations. Van Gogh's perception of the difference between his own creativity and Gauguin's would continue to be a point of tension between the two throughout their nine weeks together in Provence.

It is hardly surprising van Gogh was apprehensive that Gauguin would dislike Arles. He himself occasionally made dismissive comments about the locals, such as, "The carelessness, the lazy happy-go-lucky ways of the people here are beyond belief; you have trouble getting the most trifling things. . . ." Lenthéric's judgment of Arles's social decline was scarcely harsher. Having been deserted by the old land-owning classes, the town, according to the author, was now inhabited by:

marines, most of whose commanding officers are in Marseilles, businessmen, and tenant-farmers, whose masters live in the big towns. . . . Like most of the ancient towns of the south of France, the Rome of the Gauls, which was formerly noble and

elegant, is nothing but an enormous town which has an increasingly vulgar and plebeian look to it. Each day its appearance, originality, and character are disappearing. It has a deserted port, almost empty streets, and the landscape around is bare and sad; solitude and sickness surround it. It bustles about in an undignified way, grows old without nobility, and agonizes without grandeur.

Gauguin arrived in Arles on October 23, 1888. Van Gogh's concerns about Gauguin's opinions of Arles were well founded. Gauguin's response to the town was similar enough to Lenthéric's to make one wonder if the artist had perused his book. However, while he reacted in a similarly negative way to the meanness of the surroundings, he did seemingly steer van Gogh toward Arles's historic and cultural wealth. They both painted the Alyscamps, and van Gogh tackled a view of the ancient arena. But Gauguin clearly arrived with one predetermined objective. He wanted to discover the famed Greek beauty of the Arlésiennes, considered the legacy of this ancient settlement's unique pre-Roman ethnicity—the resulting union between the Celtic peoples (whose own origins were held to be Asian) and the colonizing Greeks. On this point, Lenthéric was clear: "What can be affirmed is that Greek beauty exists in Arles, and exists among the women alone." Gauguin quickly found such attractions in the dark features and

noble carriage of Madame Ginoux, the café proprietress, who agreed to sit for both artists. Gauguin then introduced her into *Arlésiennes (Mistral)* (fig. 22)—essentially an imaginary reworking of Place Lamartine, in which she leads a procession of somber, dignified local women.

It was van Gogh who probably took the leading role in pursuing the theme of portraiture and in arranging for the family of his friend Joseph Roulin, the postal worker, of whom he was fond, to pose for their portraits. The two artists also depicted Roulin's sons and their newborn baby girl. In the ideally close union of Monsieur and Madame Roulin, the Dutch artist was reminded of his own parents' marriage, and he invested his iconic portraits of them with filial reverence.

While painting the first version of *La Berceuse* (the cradle rocker or the cradle song), van Gogh suffered his first major breakdown. He had been feeling unwell in mid-October before Gauguin's arrival, although their lively exchange of ideas and the satisfaction of having realized his dream of the shared studio had restored him. But the inevitable rivalry over picture-making and the incompatibilities of their approaches overtaxed the Dutch artist. As men too they were profoundly different. Gauguin's Catholic background and experience of life had led him to adopt a ruthlessly cynical attitude toward women

63

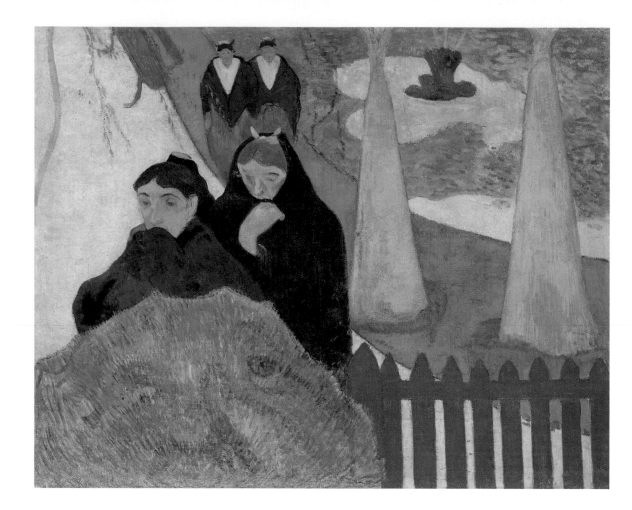

64

and the family; and his obvious ease in sexual relations was in sharp contrast to van Gogh's more scrupulous morality and awkwardness with women. Cohabitation proved to be a strain. Their relationship became increasingly fraught following the artists' trip to the Musée Fabre in Montpellier in mid-December, which provoked what van Gogh described as "electric" discussions about which artists of the past deserved great respect. On December 23, after more than two months together, following an evening's drinking bout, van Gogh threatened Gauguin with a razor and then committed a desperate act of self-mutilation: he severed part of his left ear, which he subsequently presented as a trophy to Rachel, a prostitute at a local brothel. The police were called; Gauguin wired Theo to come down from Paris and then hastily packed his bags and

left. The Studio of the South experiment seemed to have come to a disastrous end.

After a few days in hospital, van Gogh made a swift recovery from what was diagnosed as a form of epileptic attack, and by January 7, 1889, was beginning to work again, starting out with a still life. Madame Roulin resumed posing for her portrait, apparently unperturbed by recent events and local gossip about the "madman." Van Gogh felt a certain urgency, fearing that, once her husband received his new posting to Marseilles, Madame Roulin would no longer wish to sit for him. He inscribed the portrait with the words "La Berceuse." By March 1889, he had completed five versions of the subject, one of which is in the Art Institute (pl. 10), in an order that has been difficult to determine since there are no significant qualitative differences or developments to distinguish them. By the end of January, he had made three of the versions, from which he invited Madame Roulin and her husband to select one, on condition that whichever they chose should be left with him long enough for him to paint an identical copy. It would stand to reason then that the version they picked would be nearly identical to another. The two versions that are closest to each other are now in the Art Institute and the Museum of Fine Arts, Boston. However, Madame Roulin subsequently changed her mind and opted for the canvas now

in the Annenberg Collection (fig. 23), which she took away by late February. This is the only one in which the model's right hand is on top, and it was probably painted first or second. The artist regarded it as "the best." In all the others, the left hand, with its wedding ring displayed, is uppermost.

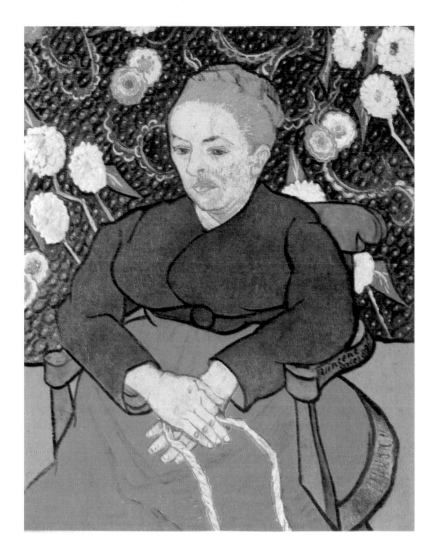

23. *Madame Roulin Rocking the Cradle (La Berceuse)*, 1889. Oil on canvas; 93 x 74 cm. The Metropolitan Museum of Art, New York, The Walter H. and Leonore Annenberg Collection, partial gift of Walter H. and Leonore Annenberg, 1996.

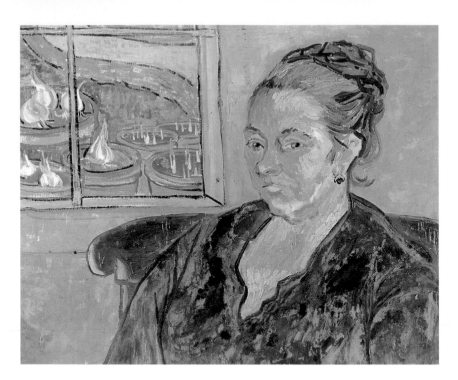

24. *Madame Joseph
Roulin (née Augustine
Alix Pellicot)*,1888. Oil
on canvas; 54 x 65 cm.
Oskar Reinhart
Collection
"Am Römerholz,"
Winterthur.

In the Art Institute's version, Madame Roulin's hands are lightly folded in her lap and barely seem to grasp the loop of rope rising from the bottom edge of the canvas. This rope is the sole visual explanation of the painting's rocking theme, as we assume it is attached to an unseen cradle. The color scheme sets up complementary contrasts of bright greens and reds, the former spanning the full gamut from olive in the bodice to pale emerald in the skirt, the reds ranging from the solid block of vermilion for the floor to spots and streaks of orange and pink in the wallpaper and plaited hair. The model's complexion, painted in parallel strokes of yellow,

takes on a somewhat furlike texture, but van Gogh justified this heightened golden harmony by pointing out how it gained in brilliance when the portrait was flanked on each side by his paintings of sunflowers, thereby forming a kind of secular triptych.

Why did van Gogh spend so much time painting and then repainting this subject? One reason must be that he considered the portrait a successful and worthy addition to his oeuvre and wanted to disseminate it among people who mattered. Consoling, maternal images had held special meaning for him since the early 1880s, when he drew Hoornik with her baby. Now he had succeeded in creating an archetypal mother figure who could join his ongoing project of portraits of exemplary human types. On another level, he associated the image of La Berceuse with the homesick longings of long-haul fish-ermen about whom he had read in Pierre Loti's novel *An Icelandic Fisherman* (*Pêcheur d'Islande*; 1886) and with their need for images in their cabin. Van Gogh had probably discussed this rather complex idea with Gauguin, with whom the whole concept of *La Berceuse* was in any case closely connected. (He intended the Chicago version for Gauguin.)

Van Gogh had been boyishly impressed to learn that Gauguin had been a sailor in his youth, and the two undoubtedly discussed maritime

legends. Madame Roulin had first posed for them both in late November 1888, one notable instance of the painters working side by side. Perhaps, the exercise evoked in them both memories of their own mothers, or in Gauguin memories of his seafaring days. The model wore a close-fitting, green jacket and sat in the wooden armchair van Gogh had acquired for Gauguin. Indeed, van Gogh had painted the same chair, empty, with books and a candle as an emblematic portrait of his friend (1888; Van Gogh Museum, Amsterdam). Their interpretation of the details and backgrounds differs: the bodice is half open in van Gogh's version (fig. 24) as though Madame Roulin has just been breast-feeding, and tightly closed in Gauguin's (fig. 25). Whereas van Gogh handled the texture of the jacket material somewhat coarsely, Gauguin gave it a suave smoothness and included the curving chair arm, which echoes and emphasizes the sitter's matronly form. When van Gogh came to paint Madame Roulin's green-clad torso again in *La Berceuse*, he adopted the mirror image of Gauguin's solution, using the same even application of paint and giving the all-important breasts and arms still more emphatic cloisonnist contours (originally blue, they now appear black). Van Gogh's very choice of colors, red and green, seems to refer to Gauguin's predilections. Indeed, in both style and theme, the portrait

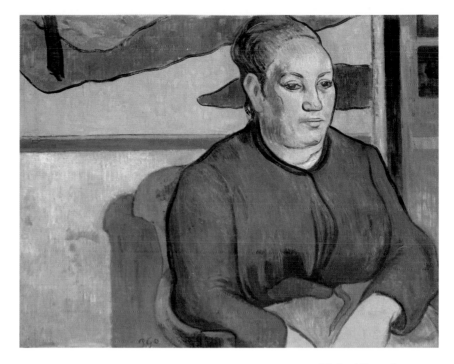

pays homage to Gauguin's more Symbolist approach, his advocacy of taking inventive liberties with nature in order to achieve a resonant synthesis. But in the background of *La Berceuse*, perhaps to avoid conceding too fully to Gauguin's precedent, van Gogh introduced a hectic floral wallpaper in green, blue, and orange, as if to demonstrate that flat planes only work when offset by patterning and texture. These designs, bursting forth in decorative exuberance, are a far cry from the prosaic background of his first portrait of Madame Roulin, which features a window ledge and flower pots containing sprouting bulbs. The crudeness of the color

25. Paul Gauguin. *Madame Joseph Roulin (née Augustine Alix Pellicot)*,1888. Oil on canvas; 48.8 x 62.2 cm. The Saint Louis Art Museum, funds given by Mrs. Mark C. Steinberg.

67

"I have wanted to express," van Gogh wrote, *"an absolute restfulness, you see, and there is no white in it at all except the little note produced by the mirror with its black frame."*

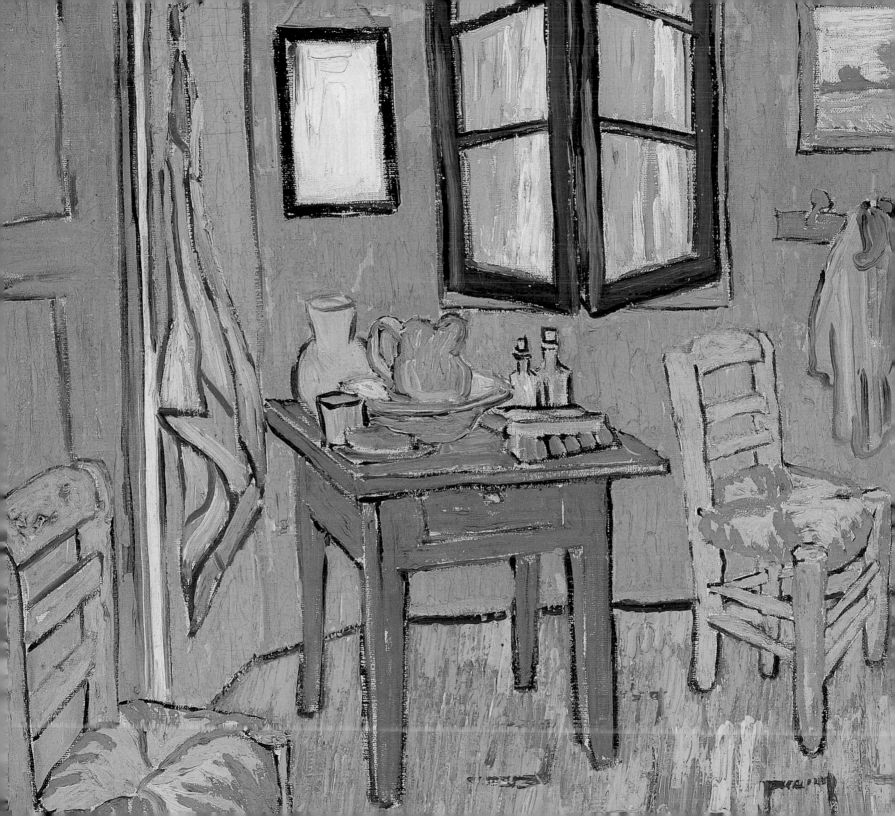

contrasts, the textural treatment of the yellow face and hair, and the homeliness of the woman are essentially van Gogh's perception.

In the early months of 1889, following van Gogh's breakdown, Gauguin's words—particularly his advocacy of greater abstraction—continued to fill the Dutch artist's thoughts. Indeed, the two men continued to correspond quite regularly, although they would never meet again. As his letters reveal, van Gogh had a strong desire to continue their dialogue; repeatedly painting *La Berceuse* was perhaps one way of doing so. But as he regained his composure, the impulse must have gradually abated. Van Gogh began to recognize that he had certain human and artistic qualities that Gauguin lacked, and that however highly he admired his colleague's art, any attempt he made to follow him down the path of imagination and symbolism was fraught with personal risk.

One of the fundamental differences between van Gogh's artistic approach and that of Gauguin lay in their drawing. Whereas for Gauguin drawing was mainly a preparatory process, a medium in which to think out ideas and to achieve simplification, van Gogh considered drawing and painting to be parallel, the former often a welcome respite from the latter or an alternative activity when he ran out of oil colors. A finished drawing, often on quite a large scale, scarcely held a lesser value in his eyes than

a completed painting, and at various times he pinned his hopes on his graphic works to win favor more readily with buyers. Theo even came to regard draftsmanship as a safer activity for his brother than painting, fearing that colors had an adverse effect on Vincent's state of mind. The symbiotic relationship between van Gogh's distinctive manner of drawing and his mature and entirely personal painting technique quickly becomes apparent when one compares the canvas *The Poet's Garden* with the drawing *Weeping Tree in the Grass* (pl. 11). For the second work, he adopted a viewpoint related to that of the painting, incorporating a triangle of path in the foreground and executing the image boldly in reed pen and ink on a full-sized sheet of his favorite Whatman paper. Unusually, the piece has escaped fading and has retained its original strong depth of tone. Its date has been debated, but it is now thought to have been executed eight months after the painting. Although its bold and rhythmic treatment of the flower-strewn grass and the conifers is directly comparable to the brushwork in the painting, there are subtle differences: the small bush in the drawing is less neat in shape (perhaps, it had yet to receive its summer trim), and the weeping tree (presumably, the same one as in the painting, seen now from a lower angle) exhibits a more schematic and patterned structure. This stylistic

tendency was developed further in 1900 by van Gogh's fellow countryman Piet Mondrian, who may have seen the drawing in 1905. It was one of the last works he completed before leaving Arles in early May and voluntarily entering the St. Paul-de-Mausole asylum, in nearby St.-Rémy.

St.-Rémy and Auvers, 1889–90

Entering the asylum in St.-Rémy had a calming effect on van Gogh. For a short time, his life was regulated by institutional routines and his fears about the recurrence of his illness abated. After a few weeks' observation, the director, Dr. Peyron, saw no objection to van Gogh resuming his work outside, even allowing him to venture into the surrounding countryside. The Art Institute's splendid drawing *Cypresses* (pl. 12), executed in June or early July 1889, testifies to this and was at least begun out-of-doors although van Gogh most likely worked up the rhythmic patterning of the surface in the room he was allowed to use as a studio. One can see evidence of van Gogh's pencil underdrawing and of his application of the pen with such force that the reed split to form parallel strokes. (Unlike the *Weeping Tree* drawing, here the ink has faded to a pale brown.) Van Gogh used the reed pen to detail the cypresses' branches as paisleylike swirls, as if the trees were entirely engulfed in flames. The group of trees stands sentinel on the flat plain, dwarfing the cottages and distant hills. It is hardly surprising that when Vincent sent this drawing and others to Paris in July 1889, Theo noticed a new fury and a greater departure from nature in the whole batch. "I shall understand them better when I have seen one of these subjects in painting," he concluded.

26. *Cypresses*, 1889–90.
Oil on canvas;
92 x 73 cm. Collection
Kröller-Müller Museum,
Otterlo.

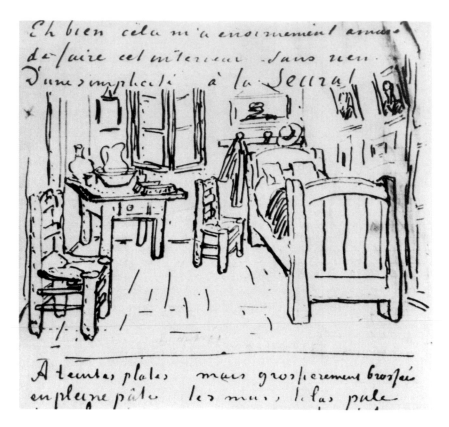

Eh bien cela m'a enormement amusé de faire cet intérieur sans rien. D'une simplicité à la Seurat

A teintes plates mais grossièrement brossé en pleine pâte les murs lilas pale

27. Sketch of *The Bedroom* (in letter to Gauguin), early to mid-October 1888. Private collection.

The oil that directly relates to this drawing, however, would not be completed until January 1890, as van Gogh was laid low by another attack in late July, while working out-of-doors, and his doctor confined him to the asylum for several weeks.

When he finished the painting (fig. 26), he added two young women dressed in mauve in the foreground and dotted the near foliage and tree trunks with warm red and orange notes to play off the dark masses of the trees. He deliberately chose a decorative color scheme: "You will see that this constitutes something like the combination of tones in those pretty Scotch tartans of green, blue, red, yellow, black," he explained. That year the cypress had become for van Gogh as typical a Provençal motif as the sunflower, and in retrospect he claimed that he had perceived them as opposites in form and color, but also as complements. Although associated with death—the planting of a cypress in the fields invariably marked a place of burial—in van Gogh's work the cypress, like the sunflower, symbolizes a universal life-force.

Perhaps the most famous work by van Gogh in the Art Institute is *The Bedroom* (pl. 13). As noted above, van Gogh first painted this subject soon after moving into the Yellow House, in the third week of October during a spell of "very fine weather." He had been suffering from eye strain, and had been working indoors to rest from the open air. This explains the quality of the light, that of the midday sun streaming through his south-facing bedroom window, with the shutters partially drawn. In a letter to Gauguin written just after painting this subject, he drew a sketch of it (fig. 27) and described it thus:

I have done, still for my decoration, a size 30 canvas of my bedroom with the white deal furniture. . . . Well, I enormously enjoyed doing this interior of nothing at all, of a Seurat-like simplicity, with flat tints, but brushed on roughly, with a thick impasto, the walls pale lilac, the ground a faded

broken red, the chairs and the bed chrome yellow, the pillows and the sheet a very pale green-citron, the counterpane blood red, the washstand orange, the washbasin blue, the window green. By means of all these very diverse tones I have wanted to express an *absolute restfulness*, you see, and there is no white in it at all except the little note produced by the mirror with its black frame (in order to get the fourth pair of complementaries into it).

In another letter about *The Bedroom* to Theo, Vincent stressed "how simple the conception is. The shadows and the cast shadows suppressed; it is painted in free flat tints like Japanese prints."

The subject and composition of *The Bedroom* have a very immediate and intimate appeal. The Spartan simplicity answered the needs of its inhabitant and suited the climate perfectly: the colors evoke the Mediterranean region's languorous siesta hour, although it is doubtful whether van Gogh observed this ritual. The confident, perspectival drawing recalls an incident that he recorded in a letter of 1882, not long after starting his artistic career. He maintained that he had finally stopped doubting whether he had it in him to become a painter when he first read a book—probably *A Practical Treatise on Perspective* (*Le Traité pratique de perspective*, [1873]) by Armand Cassagne—that clearly explains and defuses the mystique surrounding the representation of depth and distance. Van Gogh had used several of Cassagne's books as early as 1881, and asked Theo to send him this particular volume in 1888, when teaching drawing to a new acquaintance in Arles. Six years earlier, he had lost no time in putting the theory into practice by drawing the "interior of a kitchen with stove, chair, table, and window—in their places and on their legs." The memory of that early triumph seems to have remained with him, and it is almost as though here he deliberately repeated the trick here, adding the dimension of color.

As with *La Berceuse*, the Art Institute's *Bedroom* raises questions about the "originality" of multiple versions. Indeed, there remains an element of doubt as to whether it was painted in September 1889 as a repetition, or whether it might have been the "original" composition. Certainly, it was bought and first exhibited in Chicago as such. Recent scholarship, however, tends to support the view of Jan Hulsker, namely that the portraits included in the Chicago and Paris versions are not identifiable with works actually known to have been displayed in van Gogh's bedroom in October 1888. The ones in the Amsterdam version (fig. 28) can be identified as *The Lover* (left) and *The Poet* (right), both of which the artist told one of the sitters, Eugène Boch, he had hung there. Nevertheless, some of the arguments marshaled in favor of the Chicago painting's priority cannot be easily dismissed,

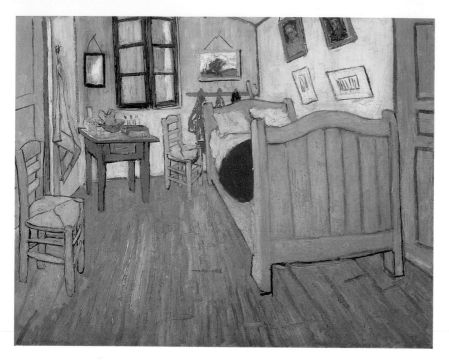

28. *The Bedroom*, 1888.
Oil on canvas; 72 x 90
cm. Van Gogh Museum,
Amsterdam (Vincent
van Gogh Foundation).

particularly the similarity of its palette to van Gogh's descriptions and the abraded condition of the surface. The various arguments are too complex to discuss fully here; what is undisputed is that the quality of the painting in Chicago is in no way inferior to that of the other two versions.

Van Gogh's replication of his own art was in no small measure a marketing ploy meant to ensure availability of his best work to all who might want it; this had been the standard practice of his early mentor Anton Mauve. However, his motivations to replicate the original *Bedroom* were rather different. Theo received the first version (fig. 28) as part of a consignment of pictures in May 1889. But its condition was poor,

because it had been painted quickly and then subjected to damp in the house, which stood empty for several weeks during van Gogh's hospitalization. As a result, the paint began to separate from the canvas. Prior to having a new backing put on it, Theo returned it to Vincent in June so that he could produce a replica, a precaution in case the original canvas was damaged during the relining process. Usually, it was Vincent himself who initiated the process of repetitions, so we can assume that Theo concurred with his brother in judging *The Bedroom* to be his best work from Arles.

In September in St.-Remy, van Gogh executed the second (the Art Institute's) and third (Musée d'Orsay, Paris; this is the smallest of the three) renditions, intended for his mother and sisters. Obviously, he had to rely on memory for the actual appearance of the space, reinforced by the original painting. He introduced slight variations to the palette and details. In the Art Institute's example, the floor, instead of exhibiting a reddish color, acquired a cooler, greenish-gray, streaky appearance, which makes the red of the coverlet stand out even more starkly. By the time he painted the two replicas, van Gogh had abandoned all hope of returning to Arles and resurrecting the Studio of the South, instead fixing his thoughts on returning north. He must have felt rueful when he considered

how short a time that restful bedroom had served its intended purpose.

Toward the autumn of 1889, van Gogh's career prospects were beginning to improve. After years of struggle, frustration that his works did not sell, and anxiety about the financial burden that supporting him had placed on his brother, there were the glimmerings of a small breakthrough to public recognition. In September, as the Exposition universelle was drawing to a close in Paris, two of his paintings appeared in the Salon des Indépendants: *Irises* (1889; J. Paul Getty Museum, Los Angeles) and *Starry Night* (1889; The Museum of Modern Art, New York). *Irises* in particular attracted favorable attention. Theo, who had married Johanna Bonger that April, could no longer store many of Vincent's canvases and was greatly relieved to find that the dealer Pére Tanguy was willing to take them. Tanguy regularly put van Gogh's work in his window, including some fine landscapes that attracted the admiration of several other artists. The Belgian avant-garde group Les Vingt was keen to show van Gogh's work at its next annual exhibition in Brussels. A Dutch art critic, J. J. Isaacson, and then another, Jan Veth, wanted to write about him in Holland. Their lead was quickly followed by Albert Aurier, an enthusiastic young critic, poet, occasional painter, and thoughtful champion of Symbolism, who,

encouraged by Bernard, planned to write about van Gogh for a French publication. Most important of all, the artist was in good shape physically, his doctor in St.-Rémy was optimistic about his recovery, and he was working well. Theo was full of praise for Vincent's recent work. Although they had had their differences in the past over art, Vincent realized that Theo's opinion was worth having, since his daily round involved looking at pictures of many different kinds. So he took note when Theo advised that "those [works] that satisfy one most . . . are the wholesome, true things without all that business of schools and abstract ideas." Theo was decidedly against artists overtly striving after Symbolist effects, as Gauguin and Bernard had been doing recently in a series of religious works, and did his best to steer Vincent away from their course.

Offsetting these more optimistic signs, van Gogh was increasingly pessimistic about his health. He feared he would never again be able to live alone, that his condition was incurable, and that the expense involved in keeping him hospitalized would become ever more burdensome. At Christmas time, almost one year after his attack in Arles, he suffered a similar breakdown in St.-Rémy. Isolated and incarcerated, he longed to return to his homeland, or at least to the North. Pissarro was looking out for a place for him to stay in northern France, although he was

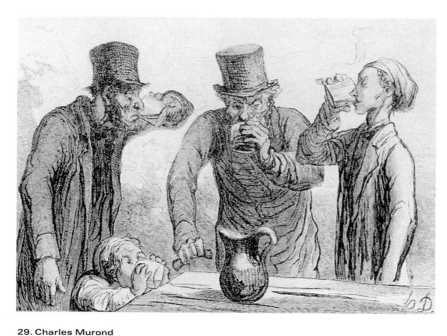

29. Charles Murond
(French; active 1860–81).
Wood engraving after
drawing by Honoré
Daumier (French;
1808–1879). *Physiology
of the Drinker—the
Four Ages,* 1862. From
Le Monde illustré,
Oct. 25, 1862.

unable, because of his wife's reluctance to house a reputed "madman," to offer him accommodation in his own home. But Pissarro was confident that he would be able to find some solution, probably with Dr. Paul Gachet in Auvers-sur-Oise.

Work was van Gogh's best defense against depression. He kept busy making replicas of his own art and copying that of others. He painted a copy of a Rembrandt etching and proposed exchanging it with Gauguin. He also returned to the art of an early hero, Millet. Theo had sent him a series of prints after Millet's "Travaux des champs" (field tasks); Vincent was enthralled by the different effects he could achieve when rendering them in color. He admitted he found it a consoling, instructive, and pleasurable activity

in his present condition. It enabled him to avoid the effort involved in original composition and to concentrate instead on interpretation; he likened his role to that of someone performing the music of another. Of course this also allowed him to pay homage to the artists he admired and to identify his name with theirs. A final, perhaps surprisingly immodest reason he gave for copying works was that he made them "more accessible to the broad general public."

Vincent asked Theo to send to St.-Rémy a number of wood engravings from his old collection; among them was a copy (see for example fig. 29) after Daumier's *Drinkers.* Dating from 1862, Daumier's image represents drinkers in the guise of the four ages of man, in a nonspecific, rural setting. It is interesting that van Gogh, who seems to have held some fairly damning views of the vulgarity and particularly the ruinous idleness of the people of Arles, believed Daumier to be the artist who interpreted their character most fully. This was an opinion he voiced several times in 1888; indeed, it was one of the points of disagreement with Gauguin, who was more inclined to interpret Arles in terms of "colored Puvis [de Chavannes] mixed with the Japanese style." We know that van Gogh saw a degree of cynicism in Daumier's aptitude for capturing the idiosyncrasies of the human figure. Malice is certainly the sentiment that pervades

his February 1890 copy of Daumier's *Drinkers* (pl. 14). Van Gogh caught both the humor of the caricaturist and the horror of alcoholism, using a greenish palette that calls to mind the notorious drink absinthe, although the four glasses seem to contain red wine, van Gogh's own favorite "poison." In order to stick closely to Daumier's characteristic outlines, the artist squared up the wood engraving onto a size twenty canvas, but took the idea one step further, setting the drinkers against a contemporary industrial backdrop. The cornfield abutting smoking chimneys evokes both Arles and Asnières. In this way, he seems to have infused his painting with a grim, Naturalist social message, suggesting that humanity's fatal flaws are hereditary, but that they are also irredeemably linked to the poisonous environment created by industrialization. As in many of van Gogh's works from 1889 and 1890, the painting harks back to his earliest years as an artist, in this case to the social concerns that were then so pressing.

The great difficulty in writing about van Gogh, apparent from the very first attempts of critics during his lifetime, has been to make a clear distinction between the man and his art, between the disturbed psychological profile and the focused, creative individual. When Aurier wrote about the artist in the *Mercure de France* in January of 1890, he entitled his article "Les

Isolés; Vincent Van Gogh." This represents the first considered recognition of van Gogh's importance as an artist, but at the same time sets him up as a marginal, isolated figure. Nonetheless, the painter welcomed the article, understanding its usefulness. He later acknowledged his appreciation in a traditional way, by giving Aurier a painting, in fact *Cypresses* (fig. 26). Van Gogh, however, called the written piece a "work of art in itself," indicating a desire to distance himself from it. Aurier certainly pointed out van Gogh's qualities, but in a highflown, richly metaphoric, Symbolist manner. He used the artist as something of a case study, first to represent a particular aesthetic shift from Naturalism to Symbolism, and second to explore the close connection between certain kinds of psychic disorders and creativity. On both counts, van Gogh must have felt uneasy and exposed.

Aurier's principal sources of information about Vincent, whom he seems to have met only briefly, were Bernard, whom he had known since 1887, Gauguin, and Theo. All three of course were in regular correspondence with van Gogh, but each had a different take on the artist. Gauguin and Bernard were both involved in Aurier's journal *Le Moderniste*, employing it as a vehicle for their own art criticism and promotion of their Symbolist ideas. Bernard, who had urged Aurier to write about van Gogh and later felt

Van Gogh was struck by the similarities he perceived between Dr. Gachet and himself, and wanted to imbue his portrait with "the heartbroken expression of our time."

aggrieved about not having been mentioned or acknowledged as the article's instigator, was a personal friend of the Dutch artist and probably supported Aurier's Symbolist reading of his art. Gauguin, fresh from his experiences in Arles, was probably anxious to keep a safe distance artistically between himself and Vincent. As for Theo (whom Aurier met in autumn 1888 and visited in early December 1889 to study Vincent's works), he was above all keen to find someone to take up his brother's cause. But one wonders whether Aurier's exploration of van Gogh's pathology and use of such language as "un cerveau en ébullition" (a brain in ferment) or "idée fixe" (obsession) about his repetitions of certain subjects may not have sent out the wrong signals to the public, possibly even triggering in the artist a deeper despair about his condition.

In the spring of 1890, Vincent took an active interest in deciding which of his works Theo was to exhibit on his behalf, both at Les Vingt in Brussels and at the Indépendants in Paris. In April 1890, Theo was able to report on the enthusiastic response his submission had received from artists whom Vincent greatly respected, among them Monet. Although he took pleasure in his upturn of fortune, feeling he was at last receiving his due, fame was something that van Gogh feared. He took his cue in this respect from the Scottish philosopher Thomas

Carlyle. In an August 1888 letter to Theo, he quoted a fable by Carlyle about Brazilian glow worms, the essential moral of which is: draw attention to yourself, become famous, and you will be destroyed. Van Gogh concluded: "I have a horror of success, I am afraid of 'the morning after the night before' of an Impressionist success. . . ." He had already experienced notoriety in Arles following the newspaper report of his self-mutilation. He had indirectly witnessed "Impressionist success," for Theo was playing a part in ensuring Monet's rising prosperity. Did he predict the same recognition would redound to himself and fear its consequences?

Since arriving in Provence, Vincent had increasingly expressed more circumspect views of Impressionism: "I hardly think that Impressionism will ever do more than the Romantics for instance," he wrote to Theo in May 1889. At the same time, many of his old enthusiasms returned, notably his admiration for Daubigny and Rousseau. He argued that they had succeeded in expressing the feelings landscape could give of "intimacy, all that vast peace and majesty, but at the same time adding a feeling so individual, so heart-breaking. I have no aversion to that sort of emotion."

In May 1890, van Gogh finally made the long-discussed move northwest of Paris to Auvers-sur-Oise, a small town where Dr. Gachet

lived. In Auvers he found a landscape that was associated closely not only with the Impressionists (Cézanne, Guillaumin, and Pissarro had all painted there and were friends of the doctor) but more particularly with Daubigny, who had built a house in the village in the 1860s. Van Gogh was enthusiastic about his new surroundings, particularly the picturesque old cottages and wide vistas of farmland that came into view as one climbed up from the Oise valley to the Vexin plain. *Cottages with a Woman Working in the Middle Ground* (pl. 15), the Art Institute's latest drawing by van Gogh, is a view of this terrain; it features a woman scything hay in the middle distance and farm buildings on the horizon. To the left is a group of tall trees, possibly an orchard, for their growth seems to be supported on poles. In the right foreground is a spindly sapling, perhaps a young fruit tree being trained to an espalier. The range of marks is reminiscent of the pen-and-ink drawing of cypresses that van Gogh did in St.-Rémy (pl. 12), but instead of relying entirely on a reed pen, the artist created a softer effect by applying ink with a brush as well. In the foreground, particularly, the freedom of his calligraphic, organic patterning anticipates the stylizations of Art Nouveau. The sky is only rapidly indicated in streaks of blue pastel and white chalk over the gray paper, but these suffice to suggest great space and depth.

30. *Doctor Gachet*, 1890. Oil on canvas; 68 x 57 cm. Musée d'Orsay, Paris.

Van Gogh found Gachet to be an intriguing, eccentric, and supportive friend. A skilled amateur printmaker, the doctor practiced homeopathic medicine and took a personal interest in the artist's case. Both he and his daughter Marguerite posed for portraits, the latter seated at the piano (Marguerite's dates from June 1890 and is in the Oeffentliche Kunstsammlung

31. Edouard Vuillard
(French; 1868–1940).
*Madame Hessel at
Home*, c.1908. Oil on
board; 28 x 27 in.
Museum of Fine Arts,
Houston, gift of Audrey
Jones Beck.

was struck by the similarities he perceived between Gachet and himself, and he wanted to imbue his painted portrait with "the heartbroken expression of our time." That desire equally may lie behind the etching, where the lines emphasizing Gachet's intelligent but furrowed brow suggest a burden of pain that is only partially offset by the reflective activity of pipe-smoking. The center of the lower edge of the image bears Gachet's monogrammed stamp of a cat; indeed, he and his son made numerous posthumous impressions from the plate. The erroneous May date may also have been given by Gachet.

In many ways, the circumstances in which van Gogh found himself in Auvers were good, but the future was uncertain. It can scarcely have been helpful to receive a letter from Gauguin, now resettled in Brittany, making it clear that van Gogh would not be well received there. Depressed in tone, the letter harps on the necessity of artists abandoning Europe if they were to survive the current economic climate, which of course van Gogh could not do, however much he agreed in principle. Despite Theo's more settled and happy family situation, with his young wife and new baby boy, which Vincent no doubt envied, he was constantly in poor health and at loggerheads with his employers. Van Gogh somehow obtained a gun, probably on the pretext of wishing to scare crows. On a hot July day, when he had been

Kunstmuseum, Basel). On one occasion, after a convivial meal, like so many artists had before him, van Gogh took advantage of Gachet's etching press to portray his host (pl. 16). The doctor's pose is close to that of the two painted portraits van Gogh had already made of him (see fig. 30; the second is in a private collection), although in the print (the only etching van Gogh is known to have made) the setting is Gachet's garden with the backdrop of a fence. Van Gogh

painting out of doors, he shot himself. After two days of agony, he died. Whether he intended to kill himself has been debated. Suicide was an act of ultimate selfishness of which he heartily disapproved in theory, but one that he had not infrequently threatened. Exactly what balance of outside factors played a part in pushing him to this act is difficult to say. What is undeniable is that it represented an admission that he could no longer face either the struggles or the successes that the future in all likelihood held.

Conclusion: Van Gogh Reaches Chicago

As a former art dealer himself, van Gogh was more sanguine than most artists about the peripatetic fortunes of paintings once they leave the studio, although even he would probably have blanched at the thought of his 1889 *Portrait of Doctor Félix Rey* (The Pushkin State Museum of Fine Arts, Moscow) being used, as it actually was, to plug a gap in a hen coop! He was also thoroughly familiar with the phenomenon of art's rise in value once the source of supply—the artist—was cut off. Unfortunately, Theo was not to be the one to benefit as Vincent had hoped, because Theo's death, in January 1891, followed his elder brother's so swiftly.

When one looks at the provenance of the works featured here, it is clear that, before finding their present, definitive home in The Art Institute of Chicago, these paintings and drawings passed through various hands, indicative of the sudden interest and market activity surrounding the Dutch painter's oeuvre after his death. Although many of the first owners were themselves painters or in some way connected with van Gogh, various key exhibitions, organized by his artist friends in Paris in the immediate wake of his death and then by dealers and critics around the world, helped to bring van Gogh's art to the attention of a broader public. In September 1890, Theo, with Bernard's help, organized a small tribute show in his apartment; Signac put together a special tribute to van Gogh at the 1891 Salon des Indépendants; and Bernard mounted a posthumous exhibition at a dealer's gallery in 1892. It is significant that the personality of van Gogh and his art had the power to cut through and unite, at least for this moment, the rival Symbolist and Neo-Impressionist factions of the Paris avant-garde.

The main source for all exhibitions and scholarship was of course the vast collection of paintings, drawings, and letters inherited by Theo's widow, Johanna Bonger-van Gogh, who, after her young husband's death, was suddenly presented with her life's work. In 1893 Bernard began publishing extracts from the letters that he had received from van Gogh; through Jo's active participation, the artist's letters to Theo

were transcribed and prepared for publication. A German edition of a selection of the correspondence appeared in 1906, preceding the first English edition by seven years.

The Art Institute's *Bedroom*, originally in the collection of van Gogh's sister Willemina, was on the Paris art market in the years before World War I. Among the dealers who handled it at that time was Jos Hessel, codirector of the Bernheim-Jeune gallery; in Edouard Vuillard's *Madame Hessel at Home*, of around 1908 (fig. 31), we glimpse the Chicago canvas, without a frame, standing on the floor and leaning against the fireplace. Chicago collector Frederick Clay Bartlett bought it from another dealer in 1926. Jack Aghion, brother-in-law of the Bernheim-Jeune brothers, seems to have been the first owner of *The Drinkers (after Daumier)*, as he lent it to important van Gogh retrospective exhibitions in 1901 and 1905.

Prompted in part by the difficulty of selling his work, van Gogh had initiated the practice of exchanges with fellow artists, which resulted in some circulation of his paintings during his lifetime. He stipulated from Arles that Gauguin should receive one version of *La Berceuse* (now in Chicago). It seems that when Gauguin departed for Tahiti in 1891, he left *La Berceuse* on deposit with Tanguy. Returning to France and finding that Tanguy had died, he wrote to the dealer's widow on March 29, 1894, to reclaim it. He was

thus able to hang it for a brief time among his own Tahitian canvases in his rented studio in Paris. The next recorded owner of Chicago's *La Berceuse* is Auguste Pellerin, a major collector of works by Cézanne. When Gauguin returned to Tahiti in 1895, he seems to have left part of his collection of paintings, including "several Van Goghs," with a café owner, presumably to pay off a financial debt. He had expected a dealer named Lévy to keep an eye on their dispersal when the time was right, but he later suspected that Lévy had double-crossed him: the dealer Ambroise Vollard bought two of these paintings, for lower prices than Gauguin would have wished. Thus, Pellerin may have purchased *La Berceuse* from Vollard.

Degas bought *Still Life with Grapes, Apples, Pear, and Lemon* in 1895; it remained with him until his death. At the posthumous sale of his vast collection in 1918, it fetched 16,500 francs. The generally high prices realized at this sale pointed the way to the boom in contemporary art sales in the 1920s, the great age of American collecting. A critic for the *New York Herald* found the prices of van Gogh's works alarmingly high. Admittedly, as the reporter for *American Art News* put it, possession by the discerning and knowledgable collector Degas had given the work "a hallmark." Interestingly, Gauguin's *Day of the Gods (Mahana no atua)* (1894; The Art

Institute of Chicago), which Degas had purchased as soon as it was painted in 1894, sold for rather less than van Gogh's *Still Life*, at 12,600 francs. Both now hang in the same room of the Art Institute, having been acquired by Bartlett in the early 1920s.

Van Gogh's work did not make its American debut until the Armory Show of 1913, which traveled to various venues, including Chicago; it came hard on the heels of Roger Fry's 1910 and 1912 "Post-Impressionist" exhibitions in London, which coined the term by which van Gogh and his colleagues would henceforth be known. But the artist's reputation as an "originator of the modern movement" was already established in France and more firmly in Germany, where forward-thinking purchases by museum directors such as Hugo von Tschudi in Berlin, the writings of art historian Julius Meier-Graefe, and the enthusiasm of Expressionist artists had given him cult status. No fewer than thirty van Gogh exhibitions took place in Germany between 1901 and 1914, the milestone in this series being the one at the Sonderbund, an art society in Cologne, in 1912. It featured five rooms of van Gogh's work, as a prelude to considerably smaller showings by Cézanne, Gauguin, Edvard Munch, and Picasso, and a mixed selection of contemporary works. Clearly, in German eyes, van Gogh was the modern master par excellence.

A significant date for van Gogh's enshrinement as a modern master in the United States was the opening of The Museum of Modern Art, New York, in 1929. Its inaugural "First Loan Exhibition" featured the four major "Post-Impressionists"—Cézanne, Gauguin, van Gogh, and Seurat—on an equal footing. But The Art Institute of Chicago had already scooped New York, because the Helen Birch-Bartlett Collection of Modern French Paintings, with its four canvases by van Gogh, was installed permanently in the museum in 1926, in a gallery specially designed by the donor. Indeed, the second marriage of Bartlett, a widowed artist, art collector, and millionaire, to Helen Birch, a fellow Chicagoan of considerable and varied talents, bore fruit in the couple's bold purchases of modern art of exceptional quality, with the Art Institute in mind. On the death of Helen at the age of forty-two, in 1925, her husband transformed the collection into her memorial. Everything suggests that she had played an important role in encouraging Bartlett as a collector to raise the stakes for large, modern works. Van Gogh's *La Berceuse* was their first notable purchase, together with Henri Matisse's *Woman Before an Aquarium* (1921). One year later, the couple made their most daring acquisition, Seurat's *Grande Jatte*. Securing this enormous and influential canvas was a major coup—it had

been sought after in New York and London—
and determined the shape of their collection
thereafter. One commentator remarked that the
respected Bartlett had not converted to the art of
the Post-Impressionists but was determined to
make "a thorough study of their methods at first
hand." Indeed, Bartlett's own, somewhat Pre-
Raphaelite decorative work is distinctly conserv-
ative compared to what he was now buying.

As we have seen, the examples by van Gogh
in the Art Institute cover most aspects of his
career and almost the full range of his media,
and include some of the salient masterpieces by
which he is known throughout the world.
Equally important, they can be seen in the
context of the many and varied artists with
whose work he was in constant dialogue. In
recent years, the Art Institute acquired the two
superb drawings from van Gogh's less-known,
but important Dutch years, the latest only in
1998. This balanced representation is remark-

able, given that the majority of these works came
to the museum as individual donations.

The tone and message of van Gogh's work
and correspondence have helped create the
mythology about what it is to be an artist in
modern society: dogged application and perse-
verance; joyous intensity of sensation; and the
concomitant necessity of experiencing suffering,
isolation, incomprehension, eccentric behavior,
and marginal, hand-to-mouth existence. Beyond
this somewhat caricatured outline, however, van
Gogh's letters reveal his admirable if idealistic
ambition to "do some good." They also contain
much sensible and practical thinking about how
to survive as an independent, radical artist in a
capitalist world, whether working alone or,
preferably, in collaboration with others. Those
ideas, for the most part, proved unrealizable in
the artist's lifetime, but, like his works, have had
much of value to offer those who came after him.

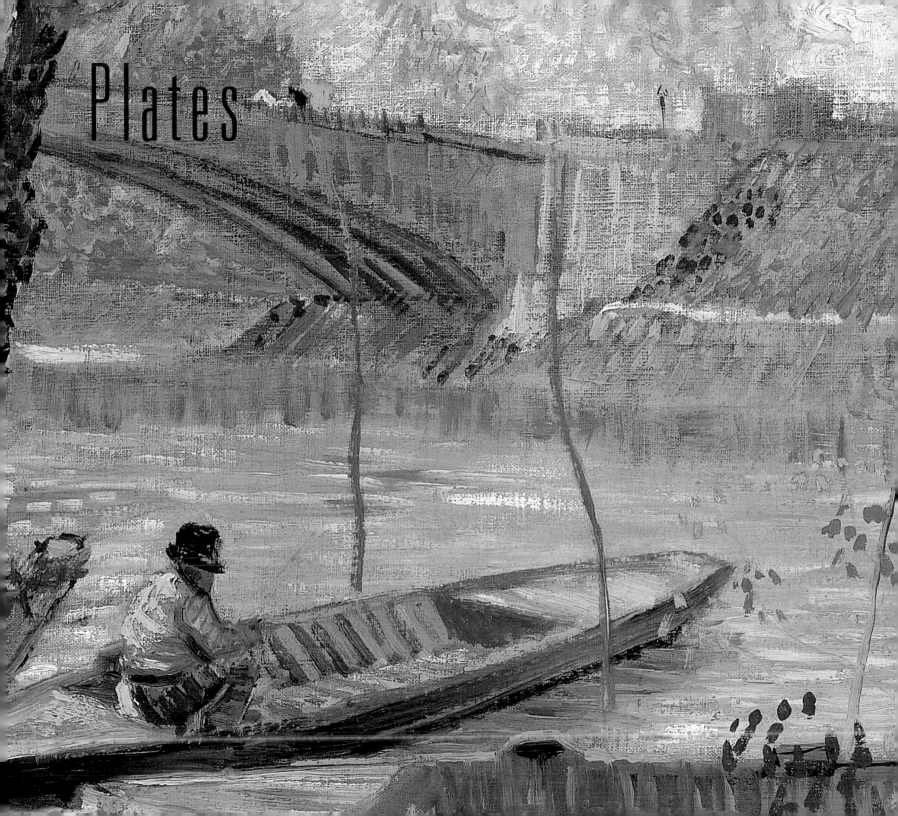

Plates

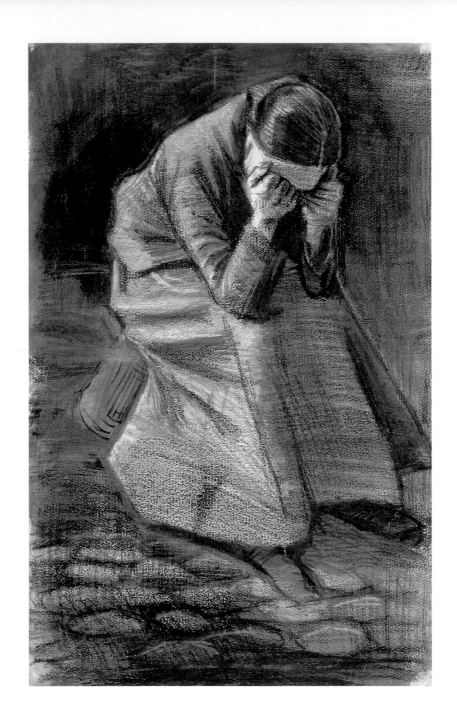

1. Weeping Woman

1883

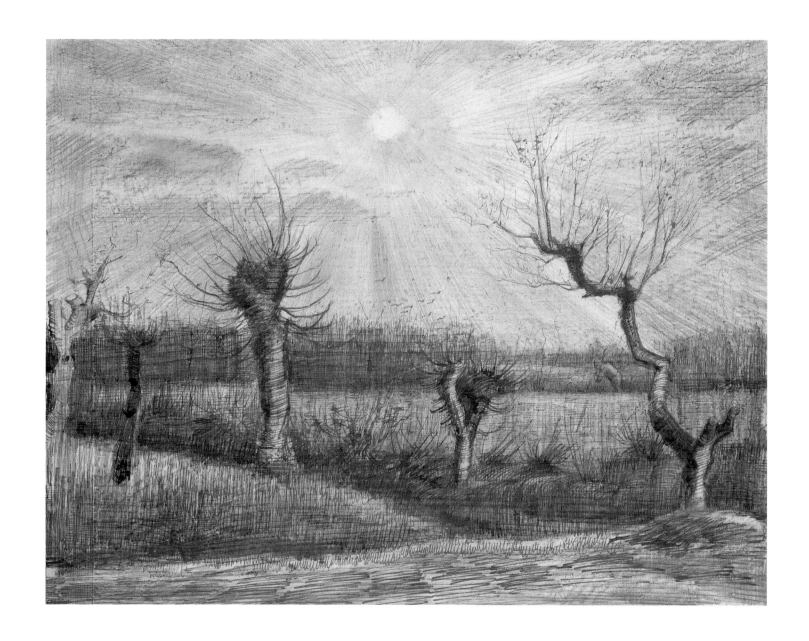

2. Pollard Willows

1884

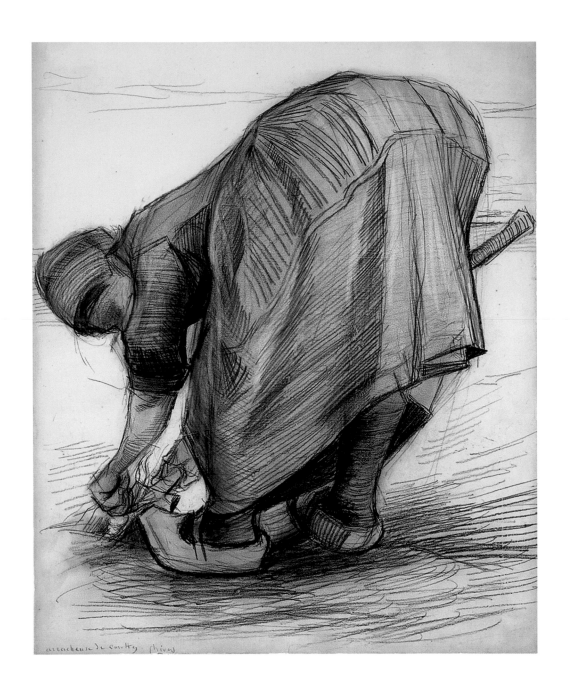

3. The Carrot Puller

1885

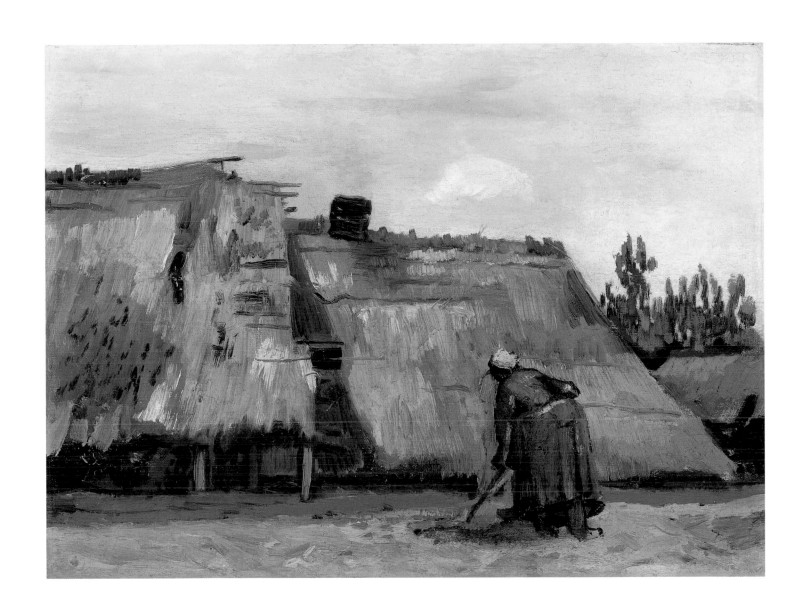

4. A Peasant Woman Digging in Front of Her Cottage

c. 1885

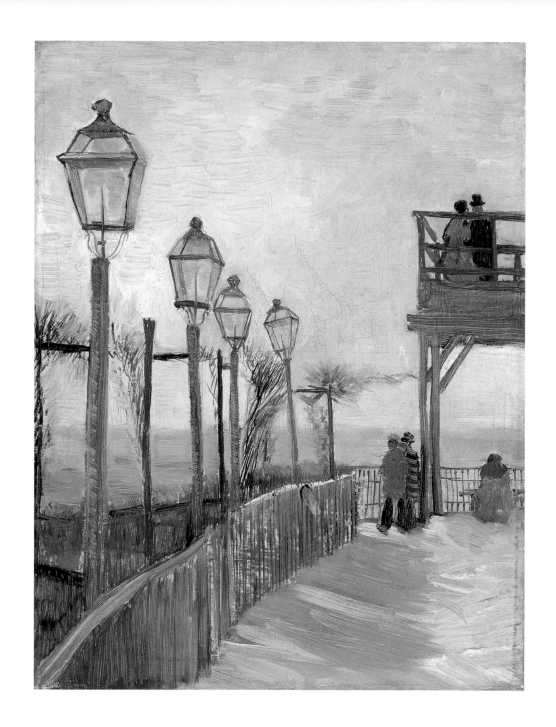

5. Terrace and Observation Deck at the Moulin de Blute-Fin, Montmartre

1886–87

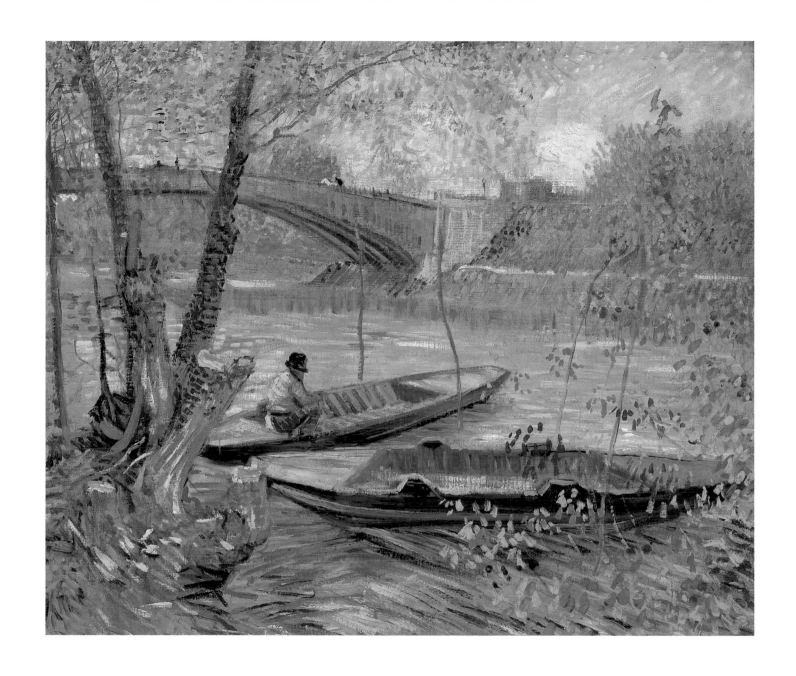

6. Fishing in Spring, the Pont de Clichy (Asnières)

1887

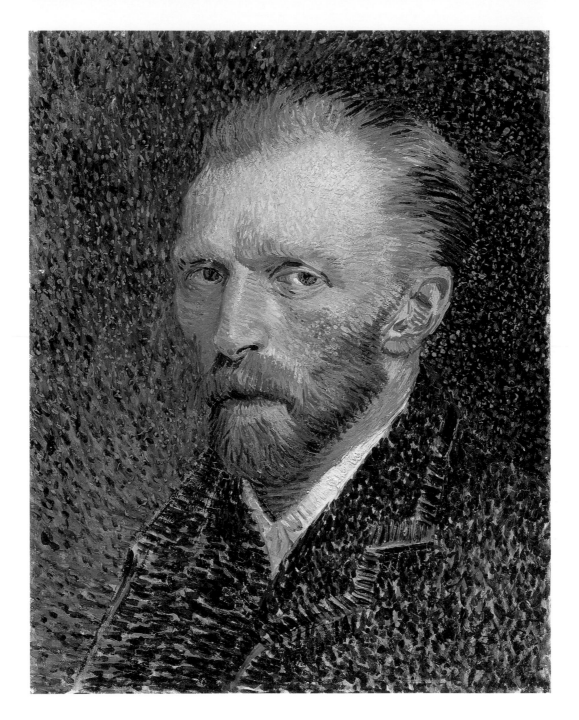

7. Self-Portrait

1887

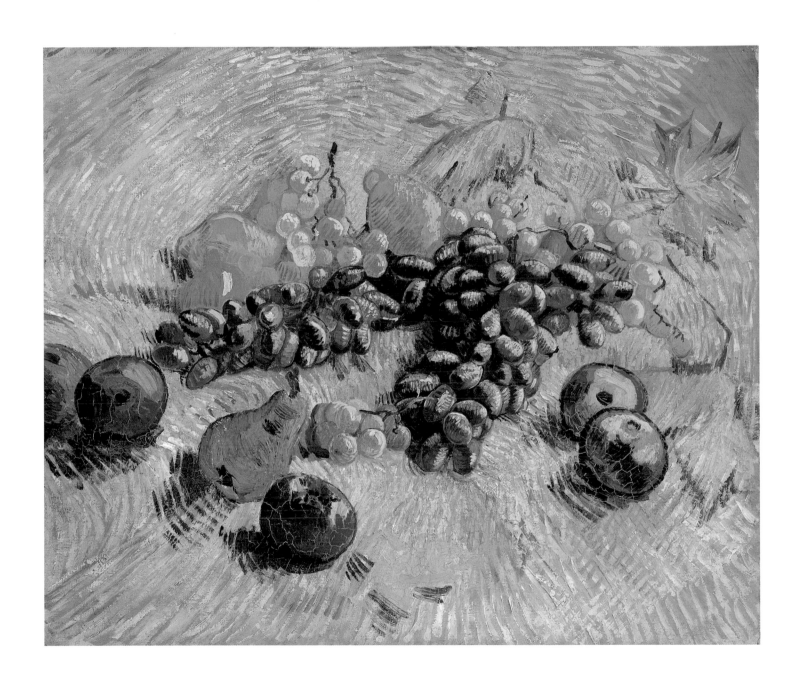

8. Still Life with Grapes, Apples, Pear, and Lemons

1887

9. The Poet's Garden

1888

10. Madame Roulin Rocking the Cradle (La Berceuse)
1889

11. Weeping Tree in the Grass

1889

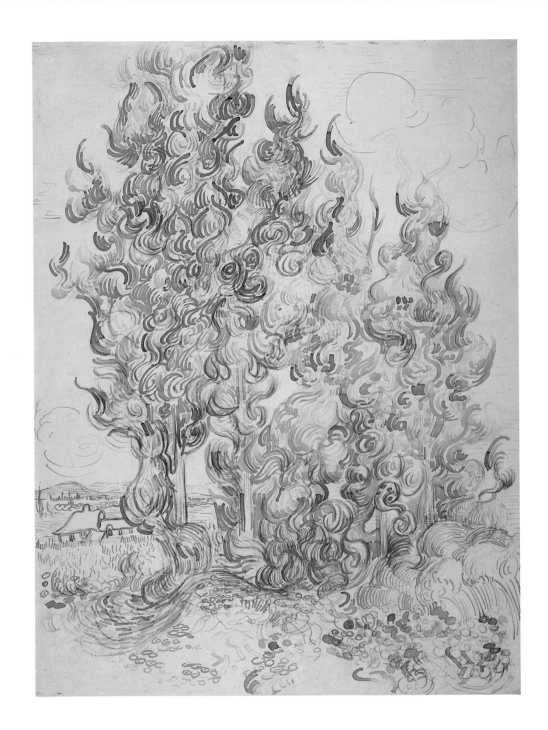

12. Cypresses

1889

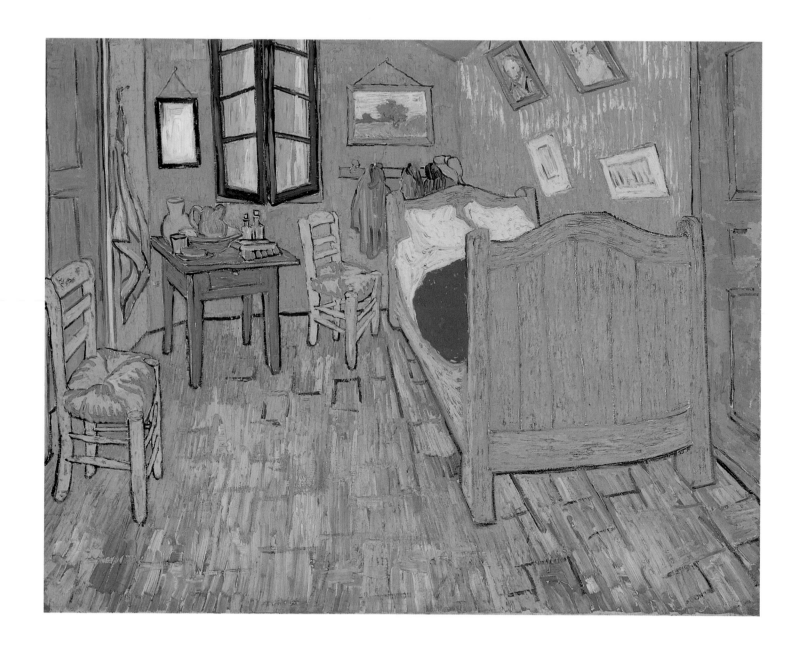

13. The Bedroom

1889

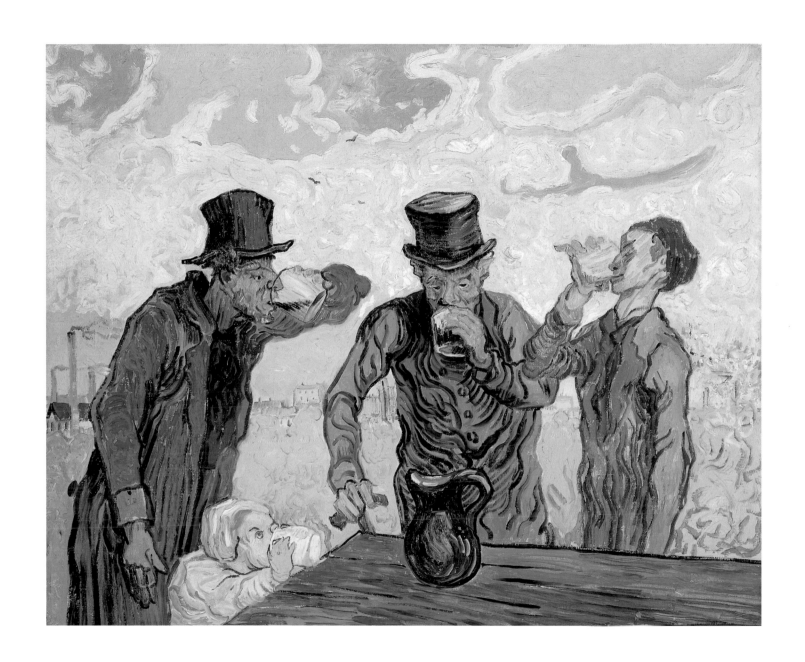

14. The Drinkers (after Daumier)

1890

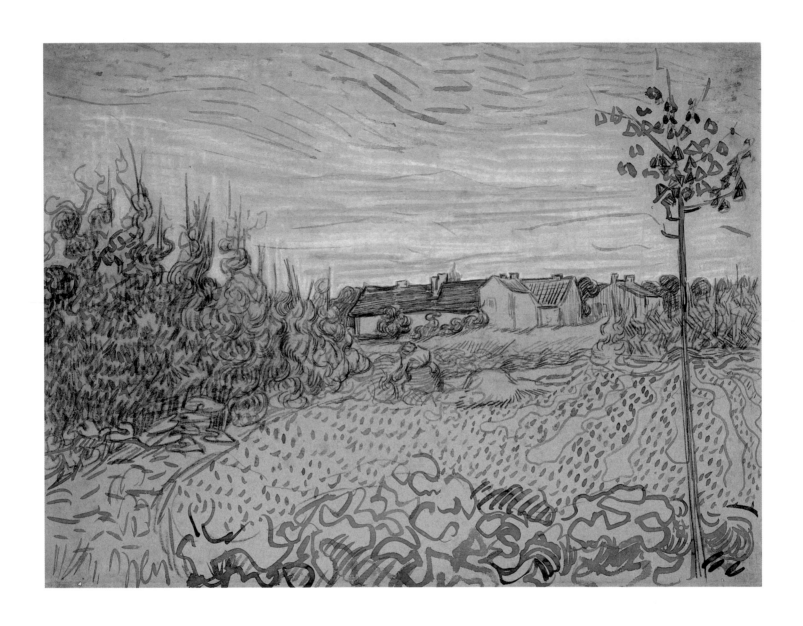

15. Cottages with a Woman Working in the Middle Ground

1890

16. Portrait of Doctor Gachet

1890

Checklist

1. *Weeping Woman*
 1883
 Black and white chalks, with brush and
 stumping, and brush and black paint and wash,
 on ivory laid paper;
 50.2 x 31.4 cm (sight)
 Gift of Mrs. G. T. Langhorne and the Mary
 Kirk Waller Fund in memory of Tiffany Blake
 and Anonymous Fund, 1947.23
 Ill. p. 88

2. *Pollard Willows*
 1884
 Pen and brown ink with graphite on ivory
 wove paper; 34 x 44 cm (sight)
 Robert Allerton Fund, 1969.268
 Ill. p. 89, detail p. 15

3. *The Carrot Puller*
 1885
 Black chalk (Bergkreide), with stumping and
 erasing, on cream wove paper; 52 x 41.5 cm
 Gift of Dorothy Braude Edinburg to the Harry
 B. and Bessie K. Braude Memorial Collection,
 1998.697
 Ill. p. 90

4. *A Peasant Woman Digging in Front of Her Cottage*
 c. 1885
 Oil on canvas mounted on pressboard;
 31.3 x 42 cm
 Bequest of Dr. John J. Ireland, 1968.92
 Ill. p. 91, detail p. 25

5. *Terrace and Observation Deck at the Moulin de
 Blute-Fin, Montmartre*
 1886–87
 Oil on canvas; 44 x 33.5 cm
 Helen Birch Bartlett Memorial Collection,
 1926.202
 Ill. p. 92

6. *Fishing in Spring, the Pont de Clichy (Asnières)*
 1887
 Oil on canvas; 49 x 58 cm
 Gift of Charles Deering McCormick, Brooks
 McCormick, and Roger McCormick,
 1965.1169
 Ill. p. 93, detail p. 87

7. *Self-Portrait*
 1887
 Oil on artist's board mounted on panel;
 41 x 32.5 cm
 Joseph Winterbotham Collection, 1954.326
 Ill. p. 94, detail frontispiece

8. *Still Life with Grapes, Apples, Pear, and Lemons*
 1887
 Oil on canvas; 46.5 x 55.2 cm
 Gift of Kate L. Brewster, 1949.215
 Ill. p. 95, detail p. 33

9. *The Poet's Garden*
 1888
 Oil on canvas; 73 x 92.1 cm
 Mr. and Mrs. Lewis Larned Coburn Memorial
 Collection, 1933.433
 Ill. p. 96, detail p. 43

10. *Madame Roulin Rocking the Cradle (La Berceuse)*
 1889
 Oil on canvas; 92.7 x 73.8 cm
 Helen Birch Bartlett Memorial Collection,
 1926.200
 Ill. p. 97, details pp. 51 and 105

11. *Weeping Tree in the Grass*
 1889
 Black chalk, reed pen and black and brown
 inks on ivory wove paper; 49.8 x 61.3 cm
 Gift of Tiffany and Margaret Day Blake,
 1945.31
 Ill. p. 98

12. *Cypresses*
 1889
 Reed pen and brown ink over graphite on
 cream wove paper; 62.5 x 46.4 cm
 Gift of Robert Allerton, 1927.543
 Ill. p. 99, detail p. 61

13. *The Bedroom*
 1889
 Oil on canvas; 73.6 x 92.3 cm
 Helen Birch Bartlett Memorial Collection,
 1926.417
 Ill. p. 100, details pp. 8 and 69, and cover

14. *The Drinkers (after Daumier)*
 1890
 Oil on canvas; 59.4 x 73.4 cm
 Joseph Winterbotham Collection, 1953.178
 Ill. p. 101

15. *Cottages with a Woman Working in the
 Middle Ground*
 1890
 Charcoal, reed pen and black ink, blue pastel,
 and white chalk on blue-gray laid paper;
 47 x 62.1 cm
 Bequest of Kate L. Brewster, 1949.382
 Ill. p. 102

16. *Portrait of Doctor Gachet*
 1890
 Etching on tan wove paper; plate: 18.2 x 14.8
 cm; sheet: 20.5 x 17.2 cm
 Clarence Buckingham Collection, 1962.83
 Ill. p. 103, detail p. 79

Selected Bibliography

Listed here are current sources on van Gogh, which offer more complete bibliographic references. I am indebted to the work of many scholars in addition to those listed. In particular I am grateful to Britt Salvesen, Katherine Reilly, and Mary Weaver at The Art Institute of Chicago for their research assistance, and as ever to Richard Thomson.

The Art Institute of Chicago. *The Helen Birch Bartlett Collection Museum Studies.* 12, 2. 1986.

Brettell, Richard R. *Post-Impressionists.* Chicago and New York, 1987.

Dorn, Roland, et al. *Van Gogh Face to Face: the Portraits.* Detroit, 2000.

Druick, Douglas W., and Peter Kort Zegers. *Van Gogh and Gauguin: The Studio of the South.* Chicago, Amsterdam, and New York, 2001.

Hulsker, Jan. *The Complete Van Gogh: Paintings, Drawings, Sketches.* New York, 1980.

Orton, Fred, and Griselda Pollock, *Avant-Gardes and Partisans Reviewed.* Manchester, 1996.

Pickvance, Ronald. *Van Gogh in Arles.* New York, 1984.

———. *Van Gogh in Saint-Rémy and Auvers.* New York, 1986.

Stolwijk, Chris and Richard Thomson, with contributions by Sjraar van Heugten. *Theo Van Gogh 1857–1891.* Amsterdam, 1999.

Van der Wolk, Johannes, Ronald Pickvance, and E. B. F. Pey. *Vincent van Gogh: Drawings.* Otterlo, 1990.

Van Gogh, Vincent. *The Complete Letters of Vincent van Gogh.* (3 vols) London, 1958.

Van Uitert, Evert, Louis van Tilborgh, and Sjraar van Heugten. *Vincent van Gogh: Paintings.* New York, 1990.

Welsh-Ovcharov, Bogomila. *Van Gogh à Paris.* Paris, 1988.

Zemel, Carol. *Van Gogh's Progress.* Berkeley, Calif., 1997.